IMAGES
of America

WETHERSFIELD

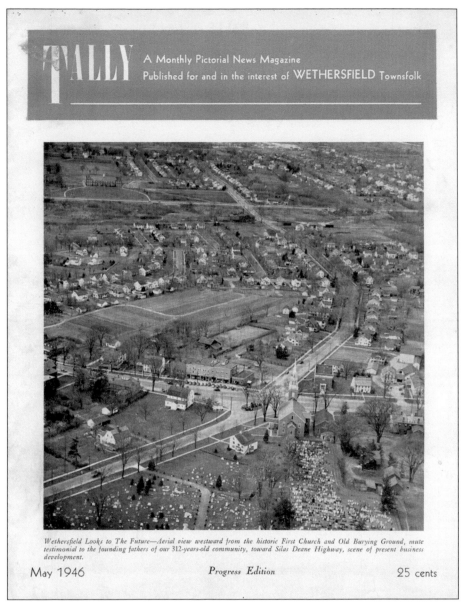

TALLY A Monthly Pictorial News Magazine
Published for and in the interest of WETHERSFIELD Townsfolk

Wethersfield Looks to The Future—Aerial view westward from the historic First Church and Old Burying Ground, mute testimonial to the founding fathers of our 312-years-old community, toward Silas Deane Highway, scene of present business development.

May 1946 *Progress Edition* 25 cents

Taken from the May 1946 issue of *Tally* magazine is an aerial view of Wethersfield, showing the northern section of town on the cusp of the largest building boom in its history. Dozens of housing projects were about to be built for returning GIs and their brides as well as hundreds of people about to migrate from Hartford to the growing suburb to its south. During the 1940s, Wethersfield's population increased 50 percent from 10,000 to 15,000; changes were inevitable and dramatic. From this viewpoint, several landmarks have not changed, including First Church, the cove, and the Keeney Center. Notice the areas that have changed: the rural character of the Silas Deane Highway in the distance, the 1930s high school to the upper left, and the pastoral landscape between the Silas Deane Highway and Wolcott Hill Road. Through assembled photograph collections such as this book, one can see changes over time and a community comfortable with both its distant and recent pasts. (Courtesy of Wethersfield Police Department.)

On the cover: Please see page 15. (Courtesy of Wethersfield Historical Society.)

IMAGES
of America

WETHERSFIELD

Beverly Lucas and Wethersfield Historical Society

ARCADIA
PUBLISHING

Published by Arcadia Publishing
Charleston, South Carolina

Printed in the United States of America

Library of Congress Catalog Card Number: 2008927937

For all general information contact Arcadia Publishing at:
Telephone 843-853-2070
Fax 843-853-0044
E-mail sales@arcadiapublishing.com
For customer service and orders:
Toll-Free 1-888-313-2665

Visit us on the Internet at www.arcadiapublishing.com

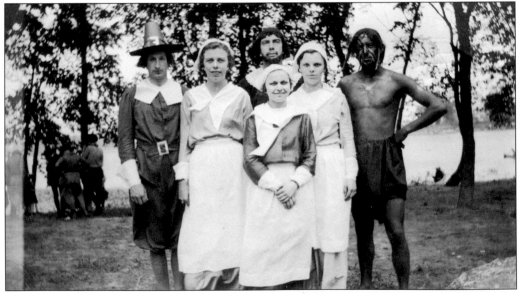

Gathered for the *Leaves of the Tree* pageant for Wethersfield's tercentenary in 1934, these young people are eager to represent their community in celebrating its early history. Seventy-five years later, Wethersfield again prepares to celebrate a milestone birthday, its 375th anniversary in 2009. Pageant participants from left to right are Winston Macdonough, Peggy Buck, Winthrop Buck, Mildred Hannum, Charlotte Buck, and Edward Cody. (Courtesy of Wethersfield Historical Society.)

CONTENTS

ACKNOWLEDGMENTS

This photograph project required the labors of many people who volunteered their time and treasures; we are extremely grateful to them all. We would like to thank the governing board of Wethersfield Historical Society, which agreed that this project highlight the anniversary year and encouraged us to think broadly to include all aspects of the town's history. Our funders, the Robert Allan Keeney Trust at the Hartford Foundation for Public Giving and the Connecticut Humanities Council, made the project a reality for which we are very grateful. We extend special gratitude to former society director Doug Shipman, who inaugurated this project and whose guidance kept us focused and on target.

We appreciate the efforts of each one of our photograph donors, more than 90 in all, who carefully selected images from their private collections and organizational archives; we regret that we do not have room to thank them all in print. Many of their photographs appear in this book. Our crew of "scanning party" volunteers shouldered the burden of learning new software, practicing excellent customer-service skills, and listening carefully for important details as they processed over 500 photographs loaned by the general public. We have enjoyed sharing interesting and fun times with the following scanning party team: Adie Beller, Carolyn Bountress, Tom and Gloria Gworek, Meg Macdonough, Jim and Marsha Meehan, John Oblak, Dana Rusconi, Bill Spigener, and Sarah Wood. Unless otherwise noted, all images are courtesy of Wethersfield Historical Society.

We would also like to thank the following individuals: Barbara Goodwin, Doug Simpson, and Edward Zito, who assisted with our photograph release forms; David Grimaldi, Barry Schlein, and Heather Willard, who input hundreds of photograph details into the society's collections databases; former society directors Nora Howard and Brenda Milkofsky, whose previously published histories influenced this one; and the hardworking "A-team" staff of Wethersfield Historical Society, who contributed to this book in more ways than they can imagine.

Finally, we would like to thank our husbands, Todd Lucas and Lucian Josefiak, who balanced our late nights with their unending enthusiasm for our work in promoting Wethersfield history.

—Beverly Lucas and Melissa Josefiak, June 2008

INTRODUCTION

The phrase "living with history" aptly describes the landscape and character of Wethersfield. Connecticut's Code of 1650 declared Wethersfield, "Ye Most Auncient Town," and townspeople have enjoyed arguing with their good friends in Windsor over founding supremacy for decades. Visiting Wethersfield has been compared to time travel—one feels transported to an earlier time—despite the modern shops and cars. Public and private preservation efforts and the collaborative works of three groups of museums strive to maintain its historic character.

The town celebrates its 375th anniversary in 2009 with a program of special events. In honor of the anniversary, Wethersfield Historical Society produced this book of photographs that captures the rich and diverse story of this town over the last 150 years. Previous historians have captured the town's history through a number of published volumes. Comprehensive tomes, scholarly monographs, and popular histories have documented the more traditional notion of history, from settlement by the Wongunk Indians to selected events in the early 20th century. This book seeks not to supplant the previous works, but to complement them. Through visual imagery, as best seen through photographs, Wethersfield's story can be told in a sharp and interesting way, up to the present day.

Even schoolchildren are familiar with George Washington's visit to town, and hundreds of well-preserved Colonial buildings are found throughout town. But what about modern history? In Wethersfield's case, modern is considered the mid-19th century to present times. With the availability of widespread photography in the 1850s, the opportunity to document the town's history through photographs coincided nicely with the modern era.

However, as this was going to be a book that told the story of the entire community, the society's photograph collections do not contain many images after the 1930s. Wethersfield has become increasingly populous and racially and ethnically diverse over the last 75 years, and the society needed to portray an accurate picture of the town's present history. The society developed a working title for the project, "My Town–Our Town," which would include as many stories from its community members as possible.

To achieve these goals, the society knew it needed to reach out to the entire Wethersfield community through interaction and involvement. Acting upon a suggestion from Arcadia Publishing, the society announced a series of "scanning parties" or public gatherings in which individuals or organizations would bring their photographs to be digitally scanned. With guidance from the society staff, trained volunteers captured important identification details about an individual's photographs and scanned them into the society's collections database. These individuals would leave with their photographs and a sense of accomplishment that they

had contributed to documenting the town's history. As the word spread about the scanning parties, new sessions were added. In all, the volunteer scanning team captured more than 500 photographs from 92 donors.

Reaction to the scanning parties proved to be overwhelmingly positive. People loved to talk about their families and describe family memories and good times. They enjoyed describing the old homestead, their third-grade class, or the awkward, staged family portraits taken at holiday celebrations. Some commonly repeated questions included "Are you sure you want this? It's just us" or "My family didn't come to Wethersfield until the 1950s and we lived in a modern house. You probably don't want to look at this." Our response continued to be "Yes we do!"

Some of the most illustrative images tended to be the candid shots that provided more clues to the town's social history than any formal gathering or studio portrait. These included photographs such as Grandma Sheehan caring for her baby chicks, Meg Macdonough lacing up her skates at the cove, and George Wilson showing off the Packard. Not only did the society volunteers enjoy the scanning parties, but members of the public did also. Many people thanked us for creating this community-history project, including their personal histories, and helping to remember their shared stories. The interaction at the parties reconnected old neighbors and former schoolmates. Although Wethersfield has a population of 26,600 people, it is still very much a small town.

With more than 500 digital photographs from the project and 1,000 from the society's collections, the selection process for the final 225 images to fit into this book proved to be the most difficult part of assembling the book. Not everyone's story could be told, and the society reluctantly made tough choices. Every organization in town was encouraged to participate through direct mailings, an informational seminar, and follow-up telephone calls. Newspaper articles, cable-access television shows, and direct mailings invited all town residents to participate. The response was strong, and those who culled through public and private archives to select their photographs are appreciated.

This book serves as a testament to those who continue to make Wethersfield a wonderful place to live and work. The spirit of volunteerism and community involvement strengthens a town already engaged in positive interaction and activism. As the town celebrates its 375th anniversary, one can see how Wethersfield enjoys "living with history."

—Melissa Josefiak, Wethersfield Historical Society

One

YE MOST AUNCIENT TOWN

Wethersfield is one of the three founding towns of Connecticut. Situated on the Connecticut River, the town has a well-documented Colonial and Revolutionary-era history and an enviable array of historic homes and public buildings that testify to the first three centuries of its community life. In 1633, John Oldham, a trader from the Massachusetts Bay Colony, visited Pyquag, the Algonquian name for what became Wethersfield. Meaning "cleared land," Pyquag was a large and fairly permanent village on the first terrace above the Connecticut River. Oldham brought 10 adventurers from Watertown, Massachusetts, to this area in 1634. Marsh hay in the low meadows and the rich alluvial soil attracted these settlers who planted farms on the broad terrace above the Connecticut River. Soon roads and turnpikes connected farmers with merchants and markets beyond the town. Shipmasters of locally built vessels carried products of farm, forest, and fishery to New York, Barbados, and beyond. The now-famous red onion was especially developed for trade and today remains a symbol of Wethersfield's roots in an agricultural past. Flax for seed, spear grass for bonnets, broomcorn, and garden seeds were also raised in support of local industries. Lacking natural waterpower for production, windmills and dams were employed to process grain and cloth and, in the Griswoldville section of town, to manufacture edged tools and run spindles.

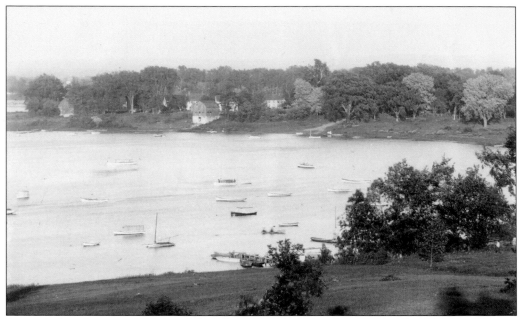

An early key feature of Wethersfield was the bend in the Connecticut River, now the cove, where the harbor, warehouses, and, by 1649, the shipyard were located. The first vessel built in Connecticut, the *Tryal*, was laid down here in 1649 by Boston shipbuilder Thomas Deming. Six warehouses along the river served the trade between Connecticut and the West Indies.

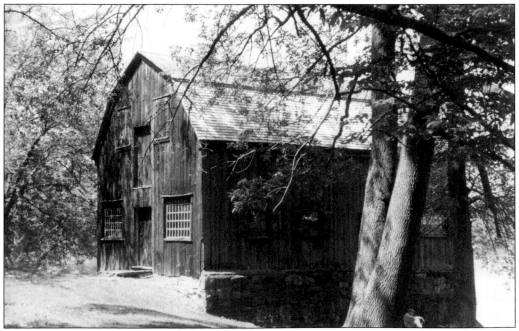

Around 1700, a great flood carried away the Hartford south meadow apparently lodging a portion of that silted material at the bend in the Connecticut River at Wethersfield. This change in the profile of the harbor led to an increase of shipbuilding and maritime activities in the Rocky Hill section of town. This event, according to tradition, also carried away five warehouses, leaving what today is referred to as the remaining Cove Warehouse.

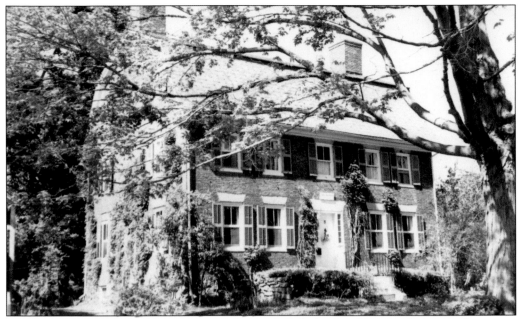

Members of the maritime community that included shipmasters, merchants, and coopers continued to build their substantial homes on upper Main Street, indicating that the abandonment of the harbor was a gradual process. Capt. Samuel Woodhouse Jr., the son and grandson of seafaring Woodhouses, built his mansion just off Main Street in 1783 when brick was the most prestigious building material in Wethersfield.

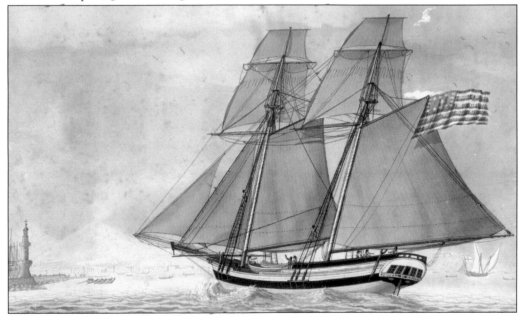

Trade from Wethersfield was primarily with the ports of Boston or New York and with the islands of the Caribbean. The schooner *Samuel*, built in 1795, was typical of the vessels that carried products, including onions, potatoes, turnips, seasonal produce, alewives, salmon, flax seed, horses, oxen, salted beef and pork, shingles, building timbers, and pipe staves. Wethersfield eventually specialized in the red onion, leading to prosperity for many local farmers.

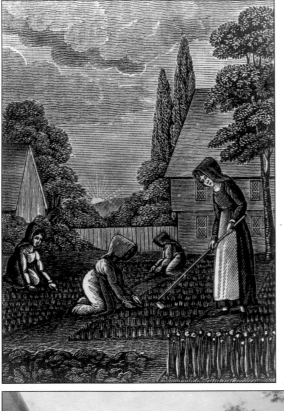

Due to the area's excellent soil, the Wethersfield red onion was extensively cultivated as a medium of exchange and gave local farmers and merchants access to markets outside Connecticut. Tended by women in their kitchen gardens and later in larger fields, the flat, red onions were shipped to southern and West Indian ports in exchange for English manufactured goods.

In addition to the compact village that developed above the Connecticut River, a second settlement was established along Two Stone Brook, which became known as Griswoldville. Adventurer Leonard Chester operated a mill in Griswoldville in 1637, although this section of Wethersfield was not settled until 1680 when Jacob Griswold put down roots. (Courtesy of Richard Griswold.)

Two

BUSINESS AND INDUSTRY

Wethersfield was initially settled by adventurers who, after finding the Massachusetts Bay Colony too crowded, sought prosperity in the Connecticut River Valley. Agriculture and maritime activities led to wealth for many Wethersfield residents. Between the 1730s and the 1830s, the onion trade brought prosperity to local farmers, merchants, mariners, and shipbuilders. The decline of the plantation system in the West Indies contributed to the demise of the primary market for onions. By 1835, shipbuilding in Wethersfield, once supported by the onion merchants, had all but disappeared from the once-active river port. Residents continued to rely on agriculture to make a living, often supplementing farm activities with fishing. The development of the seed business in the early 19th century transformed Wethersfield's inner village. Large commercial seed gardens grew behind houses and barns on both sides of Main and Broad Streets. The 1840s brought further changes to Wethersfield's agriculture, with competition from western farmers. Local farmers diversified, specializing in products that could not be easily shipped long distances. Hartford and the Connecticut State Prison provided a nearby market for milk, cream, butter, eggs, potatoes, and corn. Tobacco also became an important crop by 1860, with local farmers producing broadleaf tobacco for Connecticut Valley cigars. Industry in Wethersfield was primarily located in the Griswoldville section of town. In the 20th century, many Wethersfield residents worked in nearby Hartford, and the town began to boast service industries that met the needs of its rising population.

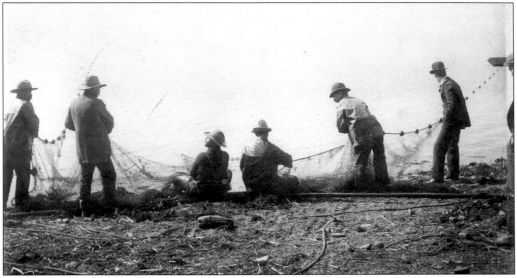

To supplement their income, many Wethersfield farmers added fishing on the cove to their seasonal activities. With the spring freshet, the alewives came up the river to spawn. Farmers fished for alewives once the ice melted through June. Early in the season, the fish sold for 18¢ per dozen, dropping to 4¢ per dozen in June.

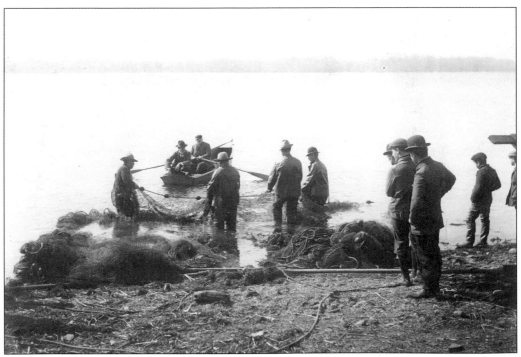

With one end of the net anchored ashore, the rest of the net was paid out across the incoming tide. When the corks began bobbing, indicating fish in the net, the boatman made a great splash, encouraging the alewives into the net. He then brought the outboard end of the net into the shallows where the fish were spooned out of the net into waiting boats.

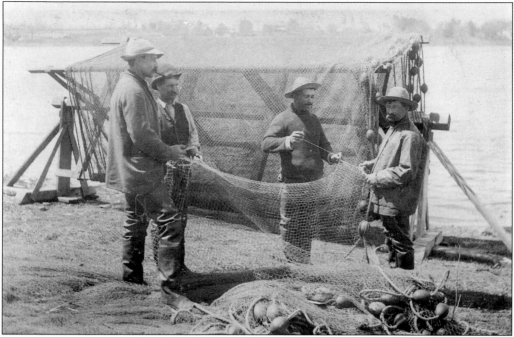

Cotton nets were spread on reels and dried at the end of each day to prevent them from rotting. Holes made in the net by underwater snags could be easily mended on the reels as well. This early-20th-century image shows the drying racks owned by the Buck family.

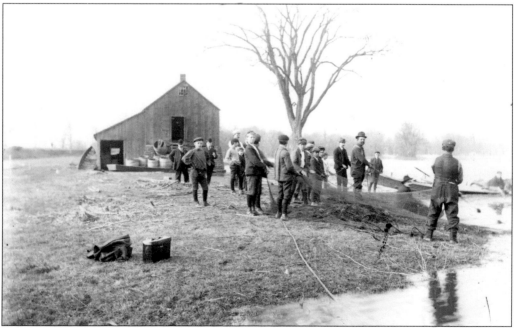

From the boat, the alewives were placed in baskets for the trip to the fish house where they were quickly emptied into barrels, 10 bushels of fish with one-half bushel of rock salt. This photograph shows the Buck fish house with men and young boys tending the nets. The Bucks used their fish house until the flood of 1936, when it floated off its foundation.

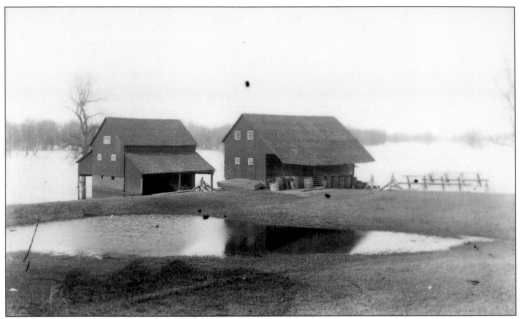

Although the catches differed over the years, the Buck, Hanmer, and Thrasher families were successful enough to maintain fish houses on the Wethersfield Cove. Peddlers arrived at the fish houses to load their horse carts with alewives to sell at Hartford markets, such as the ethnically diverse Front Street. When prices dropped, the farmers salted the alewives to ship to New York.

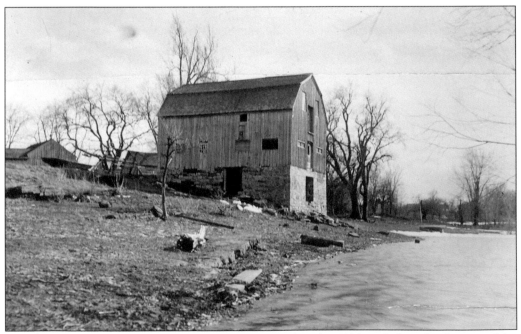

The Cove Warehouse, seen here before it was restored in the 1930s, is believed to be one of the original six warehouses. As such, the building was used to store products shipping to and from Wethersfield. In its later years, it was used as a fish house. Today the Cove Warehouse is operated as a maritime museum by Wethersfield Historical Society.

Wethersfield is located on the flat terraces of glacial Lake Hitchcock on the most fertile land in New England. The red-brown soil is relatively stone free, uniform, and easy to dig. In the 19th century, Hartford and the Connecticut State Prison provided a market for local farmers, with hay, potatoes, and corn becoming leading crops.

Elizur Goodrich, principal owner of the Hartford and Wethersfield Horse Railway, lived on Main Street in Hartford and maintained this family farm on Jordan Lane in Wethersfield. In the summertime, the Goodrich family moved to the farm, which featured a variety of barns, outbuildings, and windmills.

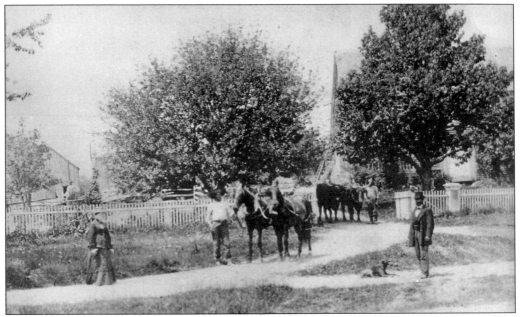

This 1877 photograph shows the James R. Anderson homestead on Broad Street. From left to right are John Johnson (hired man), Mary Reed (aunt), Mose Washington (hired man) with horses Prince and Tom, Thomas Troy (hired man) with oxen, and James R. Anderson. The Andersons began growing red onions and tobacco and then switched to dairy farming before focusing on vegetables, particularly corn. (Courtesy of James Anderson.)

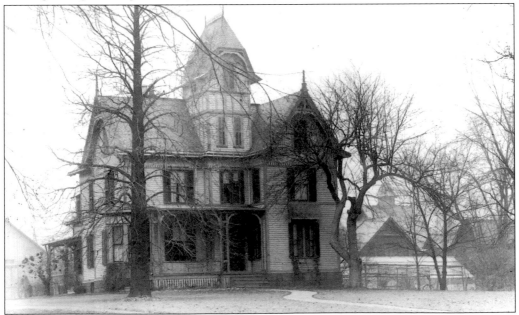

In the 21st century, only a few farmers carry on the agricultural tradition that defined Wethersfield for more than 300 years. In 1886, Anderson expanded his property by purchasing part of the extensive holdings of gentleman farmer and seed man Silas Robbins, whose barns and greenhouse can be seen in the background. Today the Andersons grow plants and vegetables for the Hartford market and their own farm stand. (Courtesy of James Anderson.)

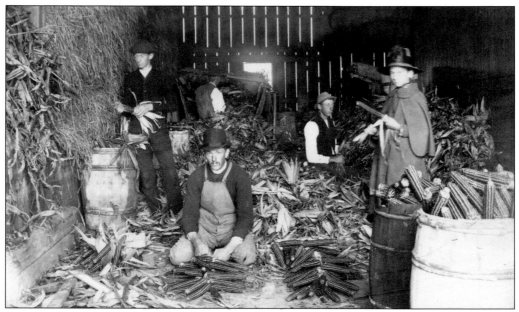

In addition to hiring outside help, entire families contributed toward securing the crops at harvest time. In this rare image, members of the Standish family shuck corn in preparation for winter storage. Pictured from left to right are J. Herbert Standish, Thomas Standish, Jonathan Standish, Edward Standish, and Emma Louise Standish.

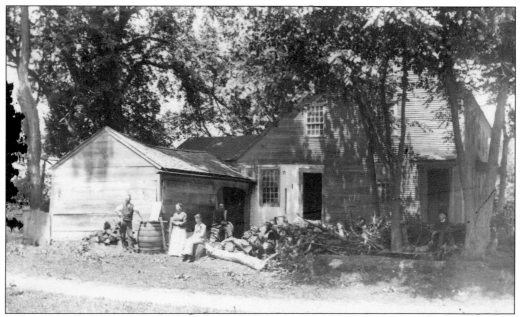

Agriculture continued to be a way of life for many in the 19th century, although Wethersfield's population fell slightly as opportunities for western land or jobs in shops attracted the town's young population. In addition to field labor, farming families undertook many chores to maintain their houses. Large quantities of wood, used to heat the home, are seen in this photograph of the Wyllys Wells House on Ridge Road.

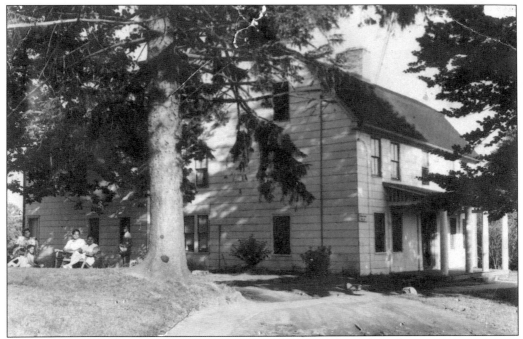

The Wood family bought the 30-acre Robbins family farm in the early 20th century on a portion of Warner Place. Seen here in the 1930s, Morgan Bulkeley Wood, his wife, Sarah, and their daughter, also named Sarah, entertained company on a Sunday afternoon. In 1958, the Woods reluctantly sold their home to make way for the approach to the Putnam Bridge. They built a new home nearby. (Courtesy of Sarah Wood.)

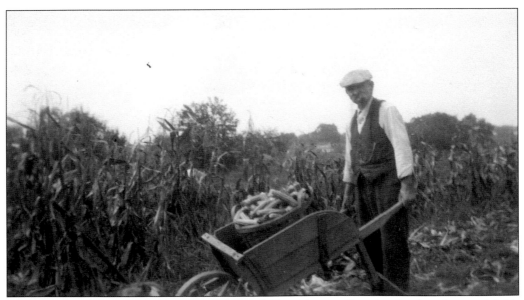

Although not full-time farmers, many Wethersfield residents still maintained gardens and fields to supply themselves and possibly the local market. In this 1935 photograph, James A. Murray is seen harvesting corn behind his home at 49 Main Street. Corn was a popular crop, which could be used to feed both people and animals. (Courtesy of Harriette Dalenta.)

This photograph shows the home of the Turner family at 52 Spring Street, originally called Mud Lane. John Henry Turner and his wife, Mary Walker Turner, most likely with her brothers, came to Wethersfield from Virginia in 1891. In this photograph, John Henry is standing in front of his house. Their daughter Elnora married into the Roane family, who lived nearby. (Courtesy of Priscilla Roane Howard.)

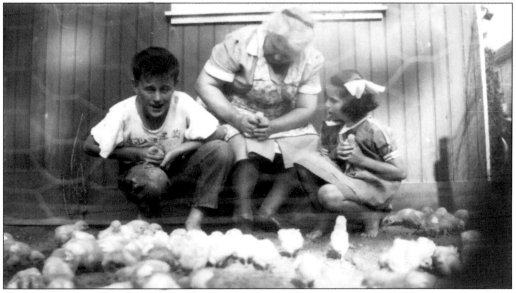

Even in the midst of a building boom and the ubiquitous automobile culture, parts of Wethersfield remained blissfully rural. Sanborn insurance maps of the mid-20th century show barns, outbuildings, storage sheds, and animal pens, even in planned neighborhoods. At the chicken coop at the family home at 90 Church Street, Ann Sheehan handles baby chicks with her grandchildren Thomas and Margaret Burlingame in this 1944 photograph. (Courtesy of John Eppler.)

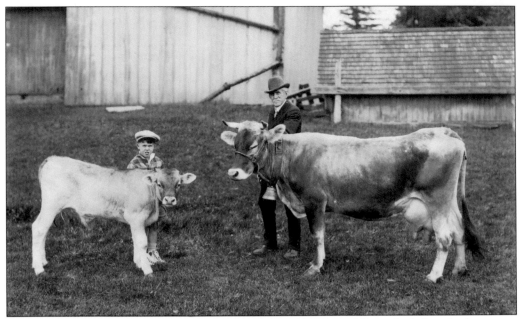

This 1931 photograph shows Gordon Harris (left) and George Harris (right) with their cows at their family farm on Prospect Street. Due to competition from western farmers who shipped grain and meat east, by the mid-19th century, local farmers diversified, and many went into those products that could not be shipped, such as milk, cream, butter, and eggs. (Courtesy of Marjorie and Gordon Harris.)

This photograph shows a large apple storage barn and a smaller tobacco storage building that once stood on the Griswold family farm. By 1860, tobacco became a very important local crop, with half of all Wethersfield farmers producing field-grown broadleaf for Connecticut Valley cigars. Both buildings were dismantled in 1985, and the area where the brick barn stood is now 100 Boulter Road. (Courtesy of Kim Wolf.)

Harry Leslie Welles (1874–1952), known as the "Horseradish King," operated a horseradish business in town from 1903 to 1947. He sold horseradish by the teacup. Welles was the first rural mail carrier in Wethersfield. A colorful character, he faithfully attended town meetings where he always stood against increasing the town budget. He was also an active member of the Wethersfield Grange, Hospitality Lodge of Masons, and the Griswoldville Sunday School.

The John Pramm House was located on the northwest corner of Mill Street and what became the Silas Deane Highway. In the 20th century, many large Wethersfield farms eventually were subdivided, as few children followed in their parents' footsteps. Agricultural land was developed with houses, businesses, and roads. The Pramm house was demolished around 1936, and much of its original acreage has been commercially developed.

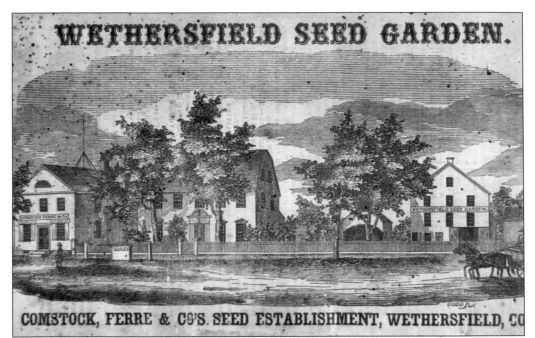

WETHERSFIELD SEED GARDEN.

COMSTOCK, FERRE & CO'S. SEED ESTABLISHMENT, WETHERSFIELD, CO

In 1811, Joseph Belden advertised "New Garden Seeds of the Growth of 1810," marking the beginning of the seed industry in Wethersfield. Little is known of Belden's ties to the seed industry, but in 1820, his brother James Belden started the Wethersfield Seed Garden on Main Street.

William Comstock and his father, Franklin G. Comstock, purchased the Wethersfield Seed Garden from James Belden in 1838. The sale included 19 acres of land, a barn, and a small inventory of seeds. Comstock's development of the Wethersfield Seed Garden, which later became known as Comstock, Ferre and Company, established Wethersfield as a prominent player in the New England seed industry.

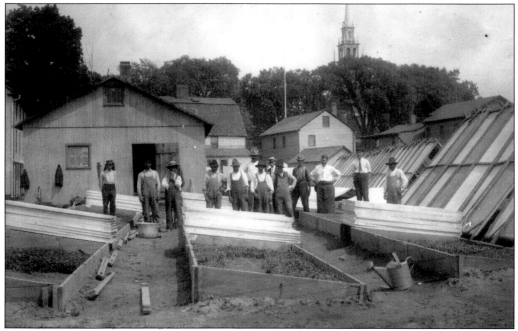

When the Wethersfield seed industry began in the early 19th century, much of the town was still open land, and seed growers owned their own acreage or contracted local farmers to produce seed. This onion house was once part of the Comstock complex. As the industry developed, both in Wethersfield and nationwide, seed production moved west.

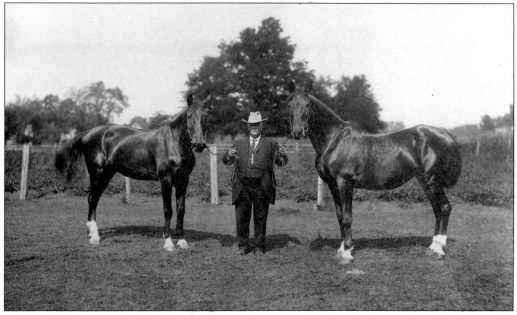

In 1866, William Meggat, a Scottish immigrant who worked for Comstock, Ferre and Company for several years, started a general wholesale seed business with Samuel Wolcott. In 1868, Wolcott withdrew, and Meggat, seen here with his horses, continued the business on Hartford Avenue for about 30 years. In conjunction with a relative living in California, Meggat was among the pioneers in California seed growing.

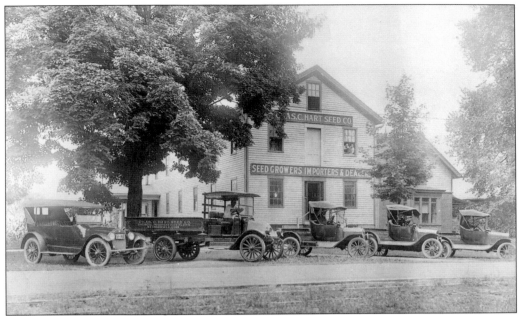

Charles C. Hart, who learned the seed business while working at Johnson, Robbins and Company, started his own business in 1892. First known as Hart, Welles and Company, the business became the Chas. C. Hart Seed Company in 1897. This 1930s photograph shows the original building of Hart Seed on the property previously used by Johnson, Robbins and Company. (Courtesy of Chas. C. Hart Seed Company.)

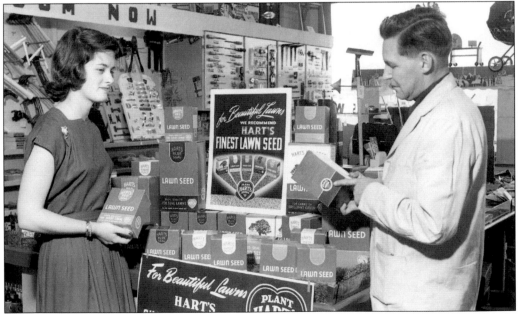

Eight seed companies operated here during the 19th and 20th centuries, with two, Comstock, Ferre and Company and Chas. C. Hart Seed Company, remaining in business today. Hart Seed started as a small consignment package-seed business, later adding mail order in 1913. Today the family-owned company produces and distributes packet seeds, bulk vegetable and flower seed, lawn seed, fertilizers, and other landscape products.

Early residents of Griswoldville pursued industry, operating mills in the area, and farming, cultivating the extensive lands in their enclave. This late-19th-century photograph shows the dam and stream, now near the corner of Highland Street and Coppermill Road, which supplied power for Griswoldville mills. (Courtesy of Richard Griswold.)

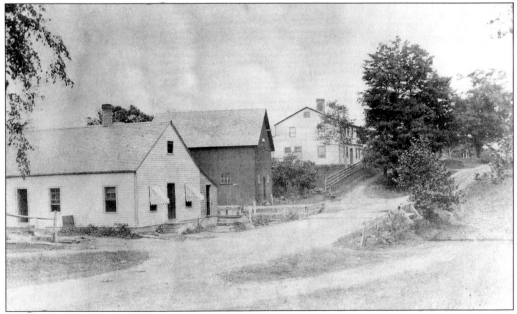

This late-19th-century image shows the Jacob Griswold House, built around 1837, on the hill with the Williams gristmill below. Mills were built on running water, and roads were created to reach them. Mills often became the center of trade, and towns such as Griswoldville grew up around them. (Courtesy of Richard Griswold.)

In 1680, Jacob Griswold settled in the Two Stone Brook area, beginning a long line of family members who lived and worked in Griswoldville. His descendant, also named Jacob Griswold, built this house around 1837. Family member Thomas Griswold introduced a power loom to weave satinet around 1825. According to the 1849 industrial census, the satinet mill produced 43,000 yards of cloth and employed 12 men and 11 women. (Courtesy of Richard Griswold.)

Samuel Broadbent Morgan (1835–1897), who served aboard a New Bedford whaler, invested part of his fortune in textile production on Two Stone Brook in Griswoldville. The mill, established around 1850, made stockinet, possibly purchased by the government for use in Civil War uniforms.

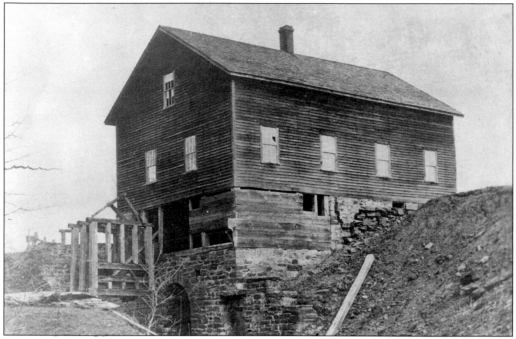

The Adams gristmill was located in Griswoldville near where Leonard Chester's mill was built in 1637. Water-powered gristmills were used to grind grain into flour and later to press apples for cider. The Adams mill was the only industrial structure to survive into the 20th century.

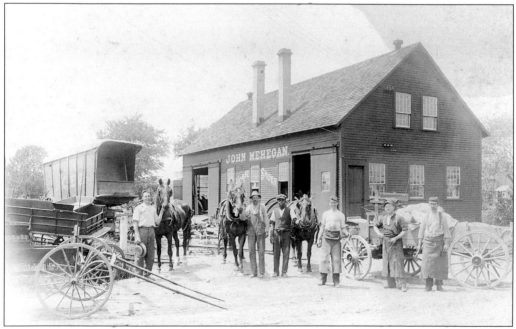

In rural areas such as Wethersfield, blacksmiths survived into the 20th century. Horses and oxen needed to be shod, wagons repaired, and hardware made. All types of metal goods could be purchased at shops such as the one operated by John Mehegan on Garden Street in Wethersfield.

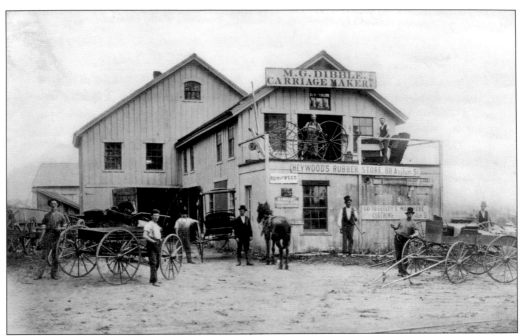

Myrton G. Dibble was a blacksmith and carriage maker and repairer in Wethersfield from 1870 to 1886. Later in business as Dibble and Standish, the shop built the first hand-drawn fire truck in Wethersfield. Known as "One Hope No. I," the ladder carrier cost $125. Dibble later left Wethersfield to set up shop in Suffield.

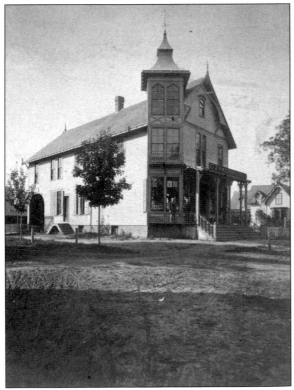

John Amidon moved to Wethersfield from Hartford around 1885 and opened a store on the corner of Hartford Avenue and Main Street in a new Victorian-style building. In the trolley suburb, corner stores were established near the car stops. Besides selling manufactured goods, the Amidon Store was the location of the first telephone in Wethersfield aside from the prison, enabling it to serve as a source of local news.

Frank Carpenter's shoe shop was located on the south side of State Street, opposite the main gate to the Connecticut State Prison. This photograph from about 1898 shows the young women who worked in the shop. When electricity was brought into Wethersfield, the shop was closed, and the business was moved to the prison where convict labor was used in the manufacture of shoes.

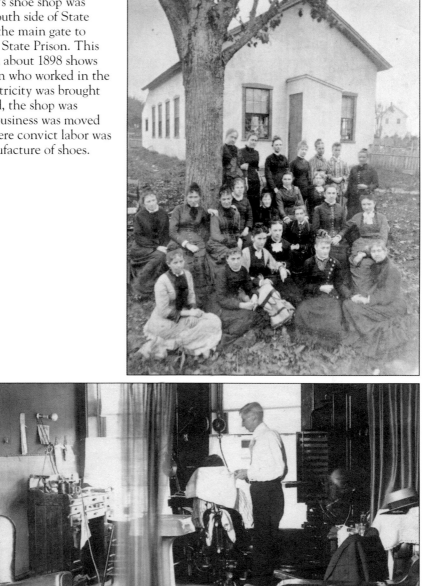

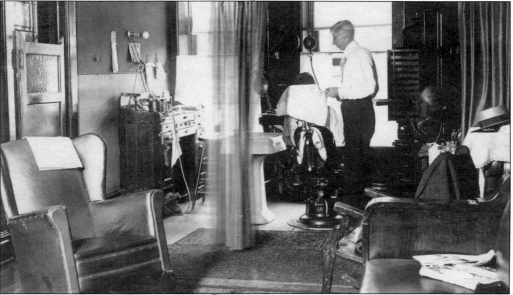

Professionals like this unidentified dentist from about 1900 provided necessary medical support to a small community such as Wethersfield. Although close to Hartford and its advanced hospitals, Wethersfield still required local support for emergencies and routine medical calls. For instance, Dr. Edward G. Fox maintained a private practice, served as the town health officer, was the only medical professional in the school system, and oversaw the recovery of the 1918 flu epidemic. (Courtesy of Pamela Hawkins.)

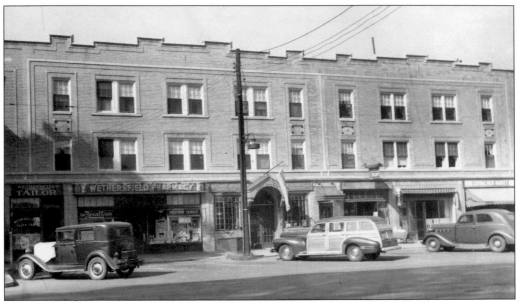

In a growing neighborhood where women were homemakers, shopping within walking distance of the house was an important asset for a growing suburb. In this photograph from the 1930s, the Baskin Block on the corner of Main and Church Streets, Wethersfield's first commercial and apartment complex, housed a drugstore, market, and post office. Somewhat controversial when it was built between 1916 and 1920, the block displaced older homes, helping to spur a preservation movement.

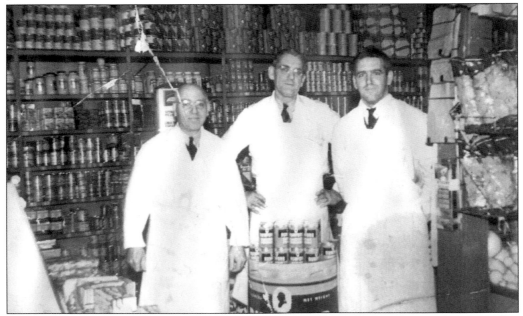

Small, local establishments succeeded thanks to local traffic. Kelly's Quality Market, located at 187–189 Main Street, stocked supplies for the village. From left to right, Bill Kelly, the owner; Gene Kelly; and future owner John McCue are seen in this 1928 photograph. Other examples of local grocery stores were First National next to the Baskin Block and Satriano's on Wolcott Hill Road. (Courtesy of Stephen Kelly.)

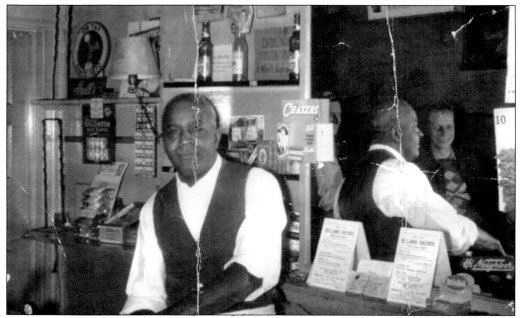

As a child, Leon William "Mose" Roane came to Wethersfield with his family in the 1890s. He purchased Duffy's Tavern from Tom Duffy in 1940 and operated the popular watering hole for 22 years. Located on Main Street next to the firehouse, Duffy's Tavern served a loyal local crowd. Seen here in the 1940s, Roane never tolerated "foul language or monkeyshines" in his establishment. (Courtesy of Stephen Kelly.)

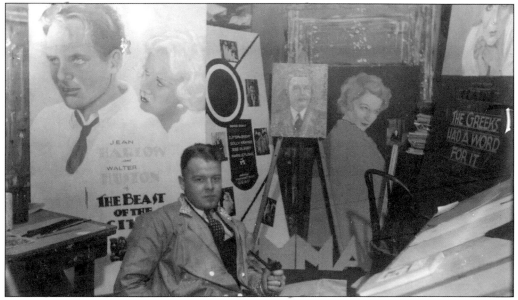

John W. Oldham Sr., seen in his basement studio at Fox Poli Capitol Theater in Hartford, began his career as an illustrator, making portraits of movie stars for theater premieres. In 1931, he founded John Oldham Art and Display. The company, which moved to Wethersfield soon after being established, specialized in theater artwork and retail window displays. John Oldham Jr. joined the company in 1965, which today is a full-service exhibit company. (Courtesy of Oldham Studios.)

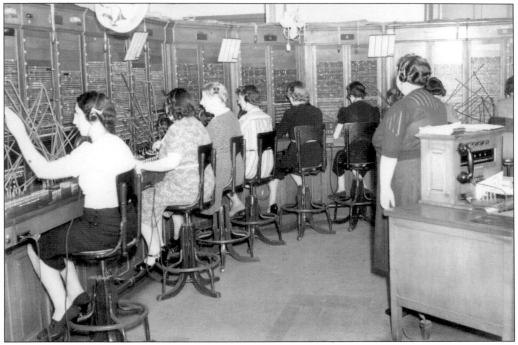

In 1939, the Wethersfield Telephone Exchange was housed in the downstairs of chief operator Elsie Grover's house, which stood opposite the Wethersfield Fire Department Company No. 1 on Main Street. Women were traditionally employed as switchboard operators. Although well staffed during the day, women such as Flora Shaw worked there alone on the night shift. (Courtesy of Janet Coates.)

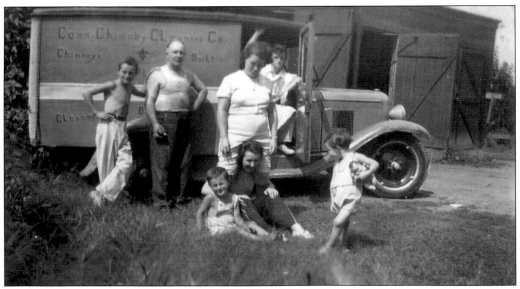

Small family-owned operations proliferated in a town with modest commercial needs. Earning a day off from work, the proprietors of the Connecticut Chimney Cleaning Company pose with their truck. In the first row, at left, is Thomas Burlingame. From left to right in the second row are Chip Langway, George Burlingame, and Margaret Eppler. (Courtesy of John Eppler.)

After serving in World War II, six brothers of the Hughes family came home to Wethersfield and established the Hughes Brothers Service Station. This 1947 photograph shows the station's wrecker in front of their business, located at the intersection of the Silas Deane Highway and Jordan Lane. (Courtesy of Joan Hughes.)

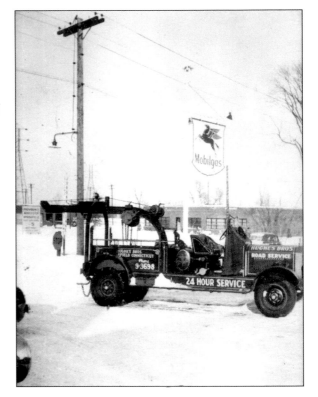

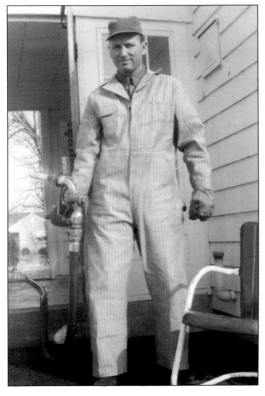

To satisfy the energy needs of a growing town, opportunities abounded for enterprising Wethersfield citizens. James Griswold ran a small oil company out of his home at 583 Maple Street between 1962 and 1980. Seen here in the early 1960s, Griswold prepares for a delivery. (Courtesy of Kim Wolf.)

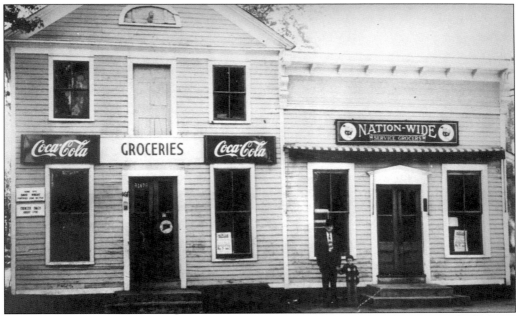

After three years of learning the general merchandise and grocery business in Hartford, A. W. Hanmer bought the firm of Dix and Welles, dealers in meats and groceries, in 1892. For 50 years, Hanmer sold groceries, drugs, grain, and coal in his Main Street store, a building erected around 1740 that he expanded several times. Hanmer also served as first selectman of Wethersfield for 46 years from 1898 to 1944.

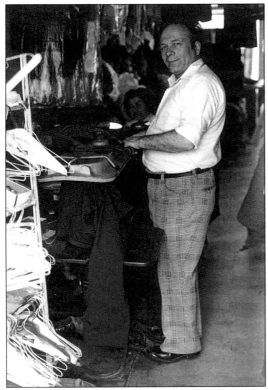

Paul and Julia Kolinsky owned Paul's Tailor Shop, located at 669B Silas Deane Highway, from 1961 to 1986. The Kolinskys immigrated to the United States from Ukraine after World War II, first settling in Hartford. They moved to Wethersfield from Franklin Avenue in Hartford in 1968. They built a house on Prospect Street, raising their family while operating the popular tailor shop. (Courtesy of Paul and Julia Kolinsky.)

Three

JUST SOUTH
OF HARTFORD

The Connecticut State Prison, built between 1823 and 1828, significantly affected the town of Wethersfield. The presence of this important state institution in town enabled many civic improvements such as city water, gas lines, and later electricity and telephone. Wethersfield was the first suburb served by the new horsecar street railway that ran past the prison in 1863. By the 1880s, Wethersfield was somewhat of a Victorian, middle-class streetcar suburb, and it was also an attractive country location for Hartford executives. In the early 20th century, agricultural lands that attracted early farmers provided choice sites for residential developments that introduced a suburban character to the town. In the 1920s, Albert G. Hubbard created the town's first significant residential development, building more than 240 houses in the historic village of town. Later developments included Westfield Heights Housing Project, created to house defense workers during World War II. Although there were no defense plants in Wethersfield, city buses conveyed workers to Hartford's many war-related factories. The post–World War II building boom filled in more of Wethersfield, and many houses were starter homes occupied by returning GIs and their brides. In the 1950s, ribbons of highway tied Wethersfield to Hartford, Connecticut's state capital and the "Insurance City," just minutes away.

The Connecticut State Prison was established in Wethersfield in 1827 when 81 prisoners were transferred from Newgate Prison in Granby. Modeled after a state-of-the-art prison in New York, the Connecticut State Prison was noted for providing solitary confinement for inmates and facilities for various workshops. In the 19th century, this imposing structure, lined with graceful elms, attracted Sunday visitors who rode the horsecar or trolley to visit the grounds.

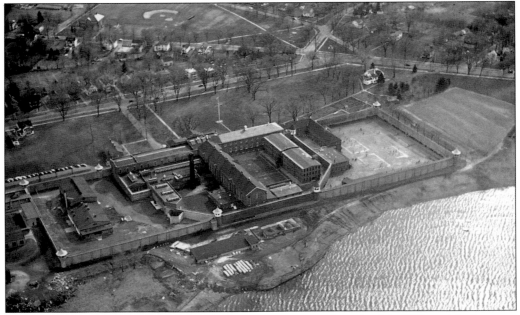

The largest building complex in town, the prison, as seen here in this 1955 aerial view, was situated on the Wethersfield Cove. Civic improvements such as city water, gas lines, electricity, and telephone were introduced early in Wethersfield to accommodate the needs of the prison. In 1963, the Connecticut State Prison moved to Enfield, and the prison complex was demolished four years later. (Courtesy of Marsha Meehan.)

Prison cells, stacked four stories high in some blocks, were seven feet long, three and a half feet wide, and seven feet high. No corporal punishment was allowed, but solitary confinement was used to discourage inappropriate behavior. For each day of solitary confinement a prisoner was given, a day was added to their sentence.

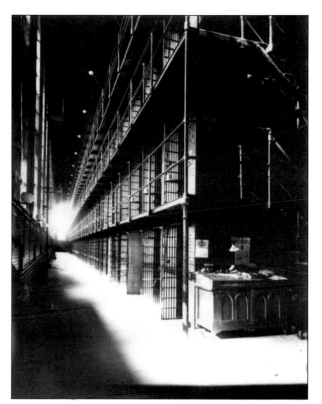

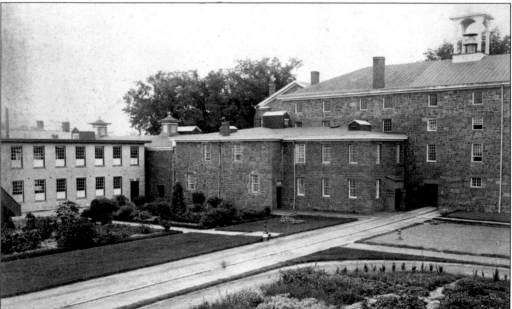

Prison reformers stressed the rehabilitative potential during incarceration. In addition to learning a trade, religious instruction, and educational opportunities, fresh air and exercise were part of the reformatory goals for certain prisoners. The main prison blocks were centered on a beautiful, open courtyard with landscaping and gardens, tended by the prisoners. At times during its history, portions of the prison were open to the public for tours.

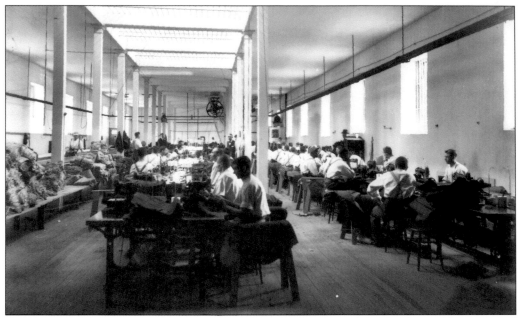

The state prison operated under the plan that prisoners were to labor by day and be separated by night. Male prisoners worked as carpenters, coopers, shoemakers, tailors, blacksmiths, nail makers, and chair makers, and the women cooked, washed and mended the clothing used in prison, and manufactured cigars. This photograph shows men working in the shirt shop at the prison.

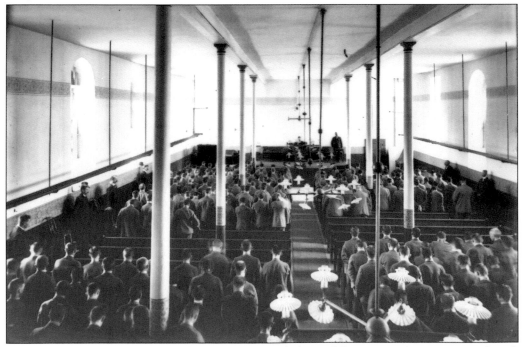

The Connecticut State Prison offered Roman Catholic and Protestant services at its chapel. Later in the day, Sunday school classes for Christian Scientist, Jewish, Catholic, and Protestant faiths were taught by Hartford area professionals who volunteered their time at the prison.

Violence was not unheard of at the prison, with five employees killed by inmates during the prison's 136-year history. Two wardens, Daniel Webster, serving from 1857 to 1862, and William Willard, serving from 1862 to 1870, were murdered by prisoners. Attempted escapes led to the deaths of night watchmen Ezra Hoskins in 1833 and Wells Shipman in 1877. In 1945, prison guard Herbert O. Parsell was killed while on duty. In 1922, a new wall with two guard towers was erected.

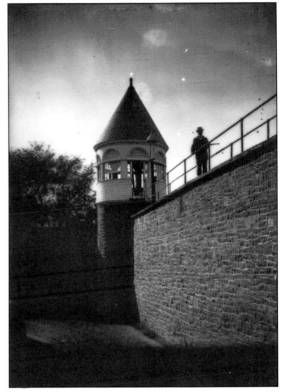

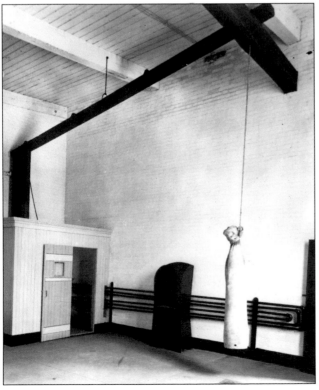

Seventy-three prisoners were executed at the Connecticut State Prison between 1894 and 1960. Fifty-five of them were hanged until this method of execution was abolished in 1936. The remaining 18 men were executed by electric chair. On May 17, 1960, the last man executed was Joseph Taborsky, who was convicted of killing six people.

The state prison was a maximum-security facility with many serving long or life sentences, such as this unidentified inmate. To the outside world, the prisoners were nameless individuals, which is most poignantly seen in the prison's burial ground. Located near the present site of the Department of Motor Vehicles, today no one knows how many prisoners, both those who died of natural causes and others who were executed, are buried in this once-forgotten cemetery.

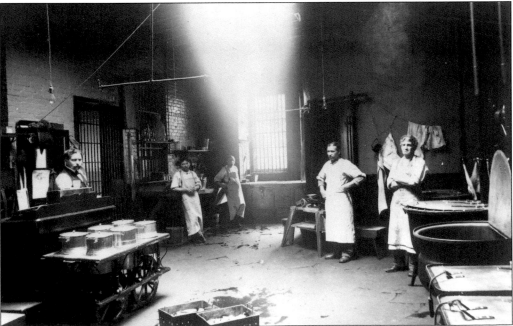

Once sentenced to Connecticut State Prison, inmates were expected to work as part of their incarceration. Approximately 16 different trades were available for inmates to earn their keep. Up until about 1880, prison labor more than supported the cost of running the facility. Prisoners in this photograph are seen working in the laundry, probably not a favorite work station for many.

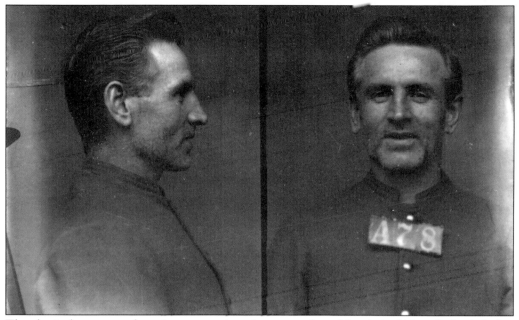

The physical presence of maximum-security prisoners, such as this criminal identified only by his number, was unnerving to most residents. Breakouts and riots were not uncommon. However, the prison's trustees, or those that were nearing parole, performed several labor-intensive jobs in town, such as mowing public areas or painting structures, both prior to the creation of and in conjunction with the town's physical services department.

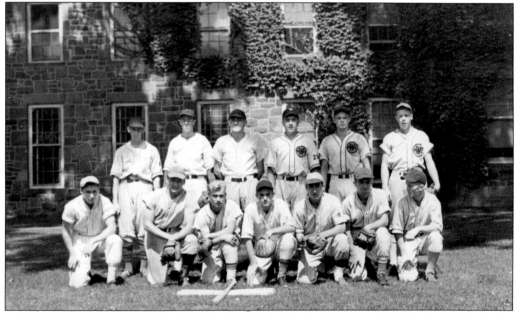

Members of the Wethersfield Athletic Club pose in front of the state prison around 1943. The team played baseball against the prison team inside the walls. From left to right are (first row) Roy Stolzenbach, Dick McCue, Doug Gilbert, Jack Donovan, Gerry Stewart, Russ Johnston, and Ed James; (second row) Tom McCue, Ken Rood, Ed Bergendahl, Bob Hungerford, Bob Johnston, and Bryan Morton. (Courtesy of Stephen Kelly.)

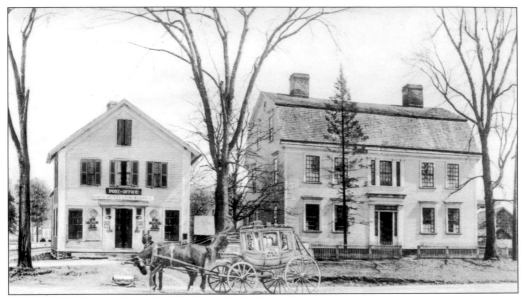

In the 19th century, the Standish General Store and Post Office served as the center of town life. In front is the Red Bird Flier, which sent its coach into Hartford three times a day. The Red Bird Stage Coach was operated by the Standish family from 1852 until 1865, when it was purchased by the Hartford and Wethersfield Horse Railway.

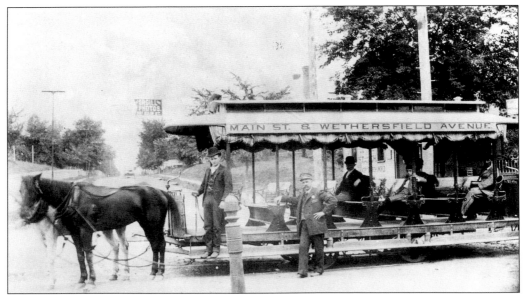

Wethersfield was the first Hartford suburb served by the horsecar. The Hartford and Wethersfield Horse Railway Company was chartered in 1859 and started its regular service in April 1863. The streetcars, pulled by horses, ran from the Old State House in Hartford to Wethersfield center initially.

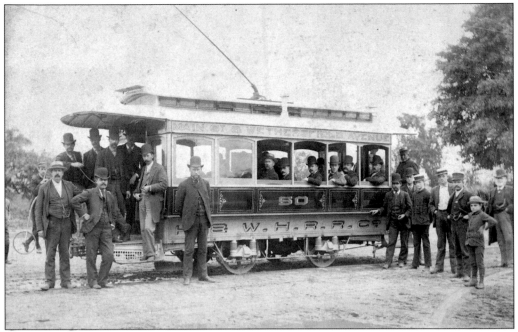

In 1893, electric trolley cars replaced the horses on the rail line. This photograph shows the trolley during its early days of operation. Trolley service was extended to Griswoldville in 1908, running along Wolcott Hill Road and up Franklin Avenue, terminating at the Old State House. Trolleys ceased operating in 1941, having been supplanted by buses.

Standing second from left, John F. Buckley Jr. was the train engineer for this valley line crew pictured at the Wethersfield train station. Taken in May 1945, this photograph commemorates Buckley's second-to-last run as chief engineer of the *Montrealer*, which ran between Montreal and Washington, D.C., daily. Although Wethersfield missed the railroad-building boom of the 1840s, in 1871, the Connecticut Valley Railroad was built through town. (Courtesy of Richard Fippinger.)

In the late 19th century, mansions were built along the Wethersfield Cove on Hartford Avenue as the town offered a country setting for executives working in the capital city. Known as "Millionaire's Row," Hartford Avenue once boasted several extensive estates. Other more modest Victorian homes, as seen here in this early-1900s photograph, were erected to house moderate-income families whose fathers worked in the city. (Courtesy of Kim Wolf.)

Largely self-contained, the prison complex, similar with any large state facility, required nearby housing for its workers. On Prison Street, presently State Street, several modest one- and two-family residences were built from the mid- to late 19th century to service the families of guards, clerks, and support staff. Located on the trolley line, these homes benefited from their proximity to the facility, as it was the first in town to receive gas, telephone, and electrical lines.

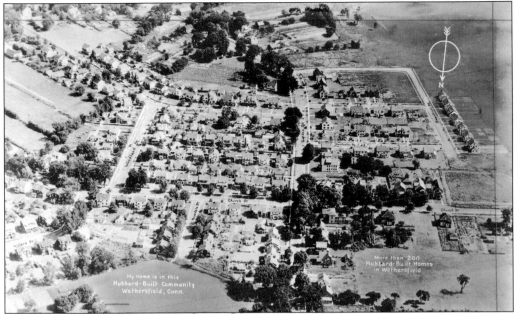

Builder Albert G. Hubbard designed and built over 200 homes on land once owned by the seed company, Comstock, Ferre and Company. The Hubbard Community, one of Connecticut's first suburban neighborhoods, included Church Street, Woodland Street, Rosedale Street, Lincoln Road, Garden Street, Belmont Street, Willard Street, Dorchester Road, Oakdale Road, Deerfield Road, Hubbard Place, and Hartford Avenue.

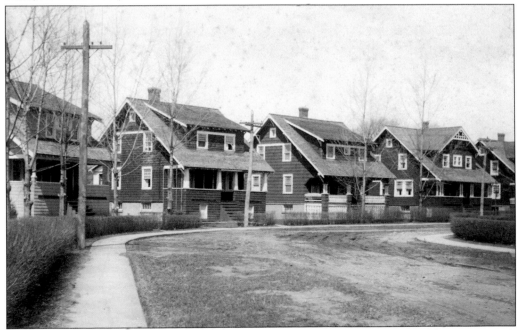

Hubbard's first neighborhood had narrow lots that maximized the number of homes on each street. The popular bungalow-style houses, as seen here on Willard Street, were built close to the narrow lanes that left no room for street trees. In the 1920s, Wethersfield began to regulate lot size and street layout, which altered Hubbard's later development. (Courtesy of Alison Tajarian.)

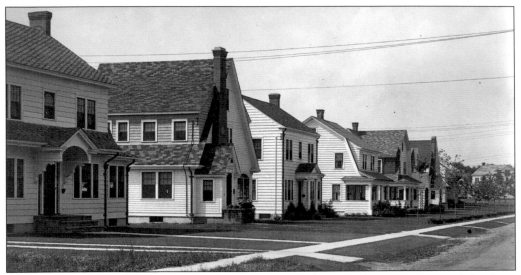

Appealing to Hartford's middle-class, white-collar workers in the insurance and banking industries, Albert G. Hubbard's homes combined the design elements from historic homes and the function of modern amenities. His Colonial Revival neighborhoods, such as Center Street, lured new suburbanites into town. His promotional brochure noted, "Wethersfield has much to commend it to the man who would be near his office, yet away from the city's turmoil."

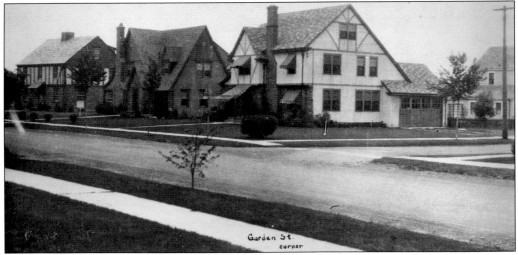

Some of Hubbard's neighborhoods were criticized in Wethersfield's planning document of 1928 for their long, narrow lots, lack of front yards, and the placement of the "car barn." Hubbard quickly altered his plans as new streets were developed, offering larger lots, longer setbacks from wider streets, and attached garages. This photograph shows larger, Tudor-style houses built along Garden Street in 1929 and 1930.

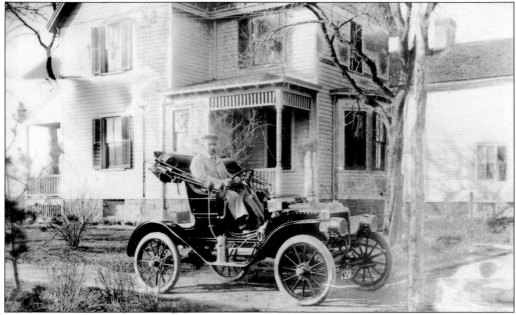

James Andrew Murray sits proudly in his car outside the family home at 49 Main Street around 1905. Murray claimed he owned the first automobile in Wethersfield and that his house was the first one in town with electricity. With dirt roads and open cars, his cap and driving coat protected him from uncertain road conditions during the early days of the automobile. (Courtesy of Harriette Dalenta.)

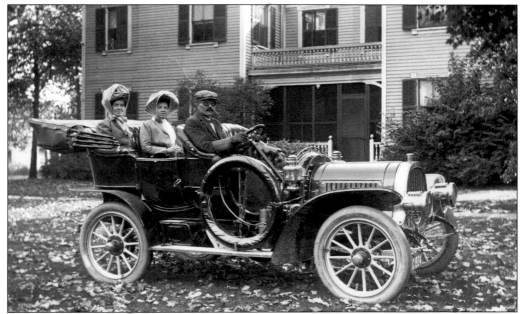

With Emil Peterson at the wheel, the Welles women, appropriately attired for a drive in their 1907 Pope-Hartford automobile, leave their home at 373 Main Street. With the advent of the automobile, road building in the capital area took on new importance. This photograph from about 1910 was taken by Wethersfield resident Richard DeLamater, a professional photographer who worked in Hartford.

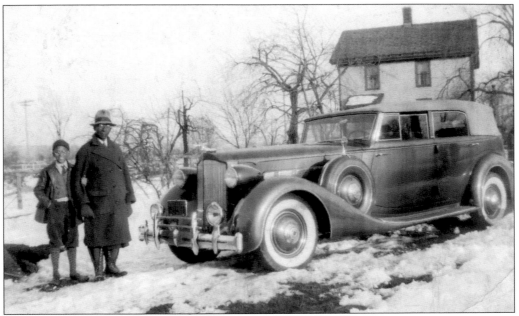

George Wilson and his nephew Howard Turner stand in front of the family home at 11 Maple Street with Ernest Wilson's 1930s Packard. The Wilson family came to Wethersfield in 1905 from Hartford. They previously emigrated with others from Tappahannock, Virginia. George worked in the shipping department of Sisson Drug in Hartford. (Courtesy of Shirley Wilson Doughtie.)

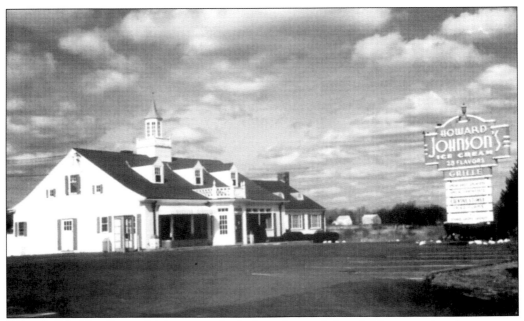

In 1930, the Silas Deane Highway was built through mostly hay fields, separating the compact "Old Wethersfield" from the brick capes and generous Colonial Revival houses being built in new neighborhoods off Ridge Road. The building of the Silas Deane Highway provided opportunities for investment in service-based businesses, including the popular restaurant Howard Johnson's. (Photograph by Clayton Maine; courtesy of Wethersfield Historical Society.)

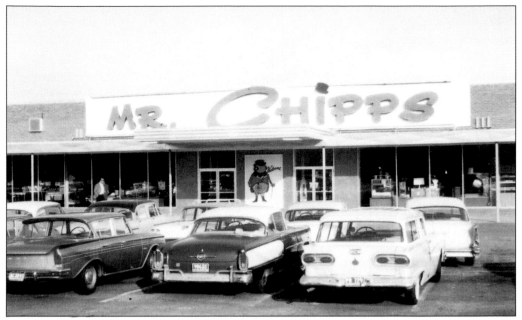

The creation of new, closely settled neighborhoods provided opportunities for small entrepreneurs to open businesses close to these new populations. Mr. Chipps was a convenient hardware store for Wethersfield residents. Today the Silas Deane Highway continues to be "the strip," housing shops that service consumers and the business community as well. (Photograph by Clayton Maine; courtesy of Wethersfield Historical Society.)

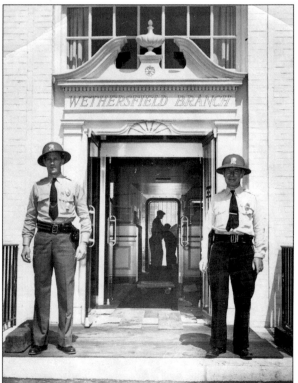

Financial institutions sprang up on the Silas Deane Highway, especially during the prosperous 1950s and 1960s. Wethersfield's first bank was quickly absorbed as a branch of the Hartford, Connecticut Trust during the financially turbulent 1930s. Subsequent mergers led to the formation of the Connecticut Bank and Trust, of which the bank became the Wethersfield branch and moved from Main Street to 600 Silas Deane Highway in 1952, shown here on opening day.

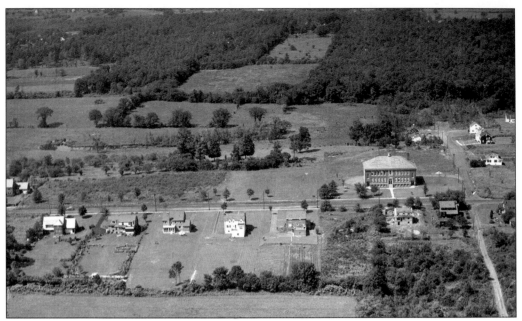

Nearly unrecognizable today, this 1941 aerial view depicts Ridge Road just north of the Wells Road intersection, facing west. Built in the late 1920s and demolished in the 1970s, Col. John Chester Elementary School stands toward the right of the photograph. The wooded acres behind the school eventually contained residential neighborhoods such as Cedar, Ivy, and Col. John Chester Streets. (Courtesy of Stephen Kelly.)

Access to rural districts was often a challenge but not insurmountable. Newsboys, such as this unidentified one with the puckish grin on Prospect Street, delivered the latest printed word from the capital city. Itinerant peddlers and gypsies wound their way through sparsely settled districts well into the 20th century. Certain areas of town enjoyed milk delivery into the early 1970s. (Courtesy of Pamela Hawkins.)

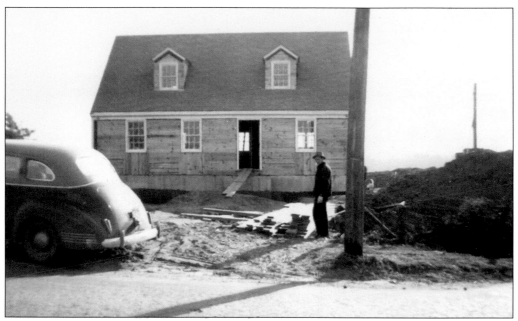

Prospect Street connects Route 3, the Shunpike, with the Berlin Turnpike in Newington. Formerly farmland, this area developed during the postwar boom and became a main thoroughfare. In contrast to the large housing tracts, some residents custom-built their homes. In this image, steamfitter Tom Oppelt nears completion on his sturdy Cape Cod house at 98 Prospect Street in 1950. The house has only had two owners. (Courtesy of Phil and Sheila Saxe.)

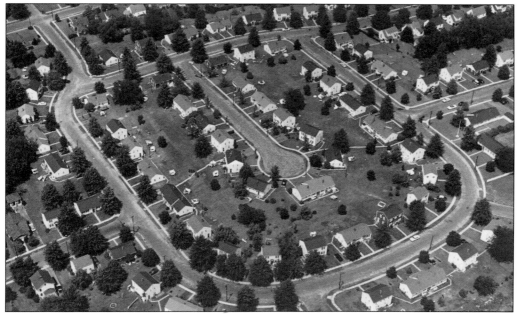

Located northwest of the Silas Deane Highway and Maple Street, Westfield Heights was the town's first housing project. Originally built to house the families of World War II defense workers for factories in Hartford and East Hartford, Westfield Heights later became housing for returning servicemen and their new brides. Demand was strong for space in the complex, and Wethersfield quickly experienced a housing shortage.

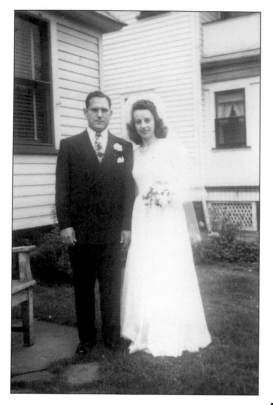

As the town's demographic pattern changed in the 20th century, patterns in its ethnic composition emerged. New immigrants to Hartford lived in the city for a generation, and the following, more affluent, first generation often moved to nearby Wethersfield. By the middle of the 20th century, many people of Irish, Italian, and Polish heritage called the town home. Anthony James DeJohn and Margaret Elizabeth Gedeon celebrate their wedding in June 1946. (Courtesy of Andrea and James Boyle.)

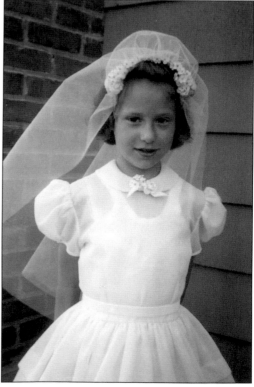

Not unlike many new immigrants to America, the DeJohn family name was changed from its original DiGiovanni. With the new immigration, Wethersfield's Roman Catholic population expanded dramatically, building new churches to accommodate them. Living on Stillwold Drive at the time, the DeJohn's daughter Paula celebrated her First Holy Communion in 1954 at Corpus Christi Church. (Courtesy of Andrea and James Boyle.)

Four

LIVING WITH HISTORY

In the early 20th century, the town of Wethersfield and its residents embraced the Colonial Revival movement that created a heightened interest in local history. This is most evident in the town-wide historical celebration of the Wethersfield tercentennial, Wallace Nutting and the Webb House, the founding of Wethersfield Historical Society, and the establishment of the town's historic district. Nutting, a leader of the Colonial Revival movement, began purchasing homes to include in his Chain of Colonial Houses, which he opened to the public. In 1916, Nutting began his last restoration project, the Webb House in Wethersfield. At the same time, Wethersfield residents expressed an interest in preserving its architectural history, which eventually led to establishing a historic district, the largest in the state, preserving a significant number of historic buildings. Wethersfield enjoys a rich architectural history with buildings dating from the 17th through the 21st centuries. The town's historical roots are most evident in the historic district, although many historic homes are lovingly restored throughout Wethersfield. Established in 1962, the historic district was formed in response to the encroachment of local residents and merchants upon the town's old village and the recent increase in commercial strip developments and multifamily housing. The historic district is approximately two square miles and includes 1,100 structures, with more than 200 built before 1850. Most of the buildings are privately owned, although houses of worship, businesses, and museums are also part of historic Wethersfield.

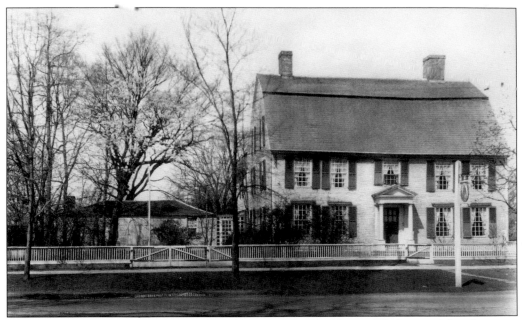

Built on Main Street in 1752, the Joseph Webb House served as George Washington's headquarters in May 1781. Washington and French commander Comte de Rochambeau planned the joint military campaign that led to victory at Yorktown, Virginia, ending the Revolutionary War. Wethersfield residents saved the house in 1915, selling it to antiquarian Wallace Nutting, who restored the house and opened it to the public as Wethersfield's first museum.

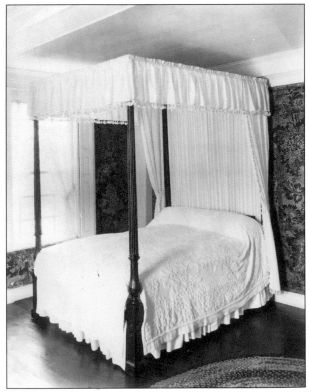

Nutting sold the Webb House to the National Society of the Colonial Dames of America in the State of Connecticut, who continue to operate the house as a museum. In May 1781, the Webbs hosted Gen. George Washington, who slept five nights in this bedroom, which still retains the flocked wallpaper from that early era. The room was preserved unaltered from this time.

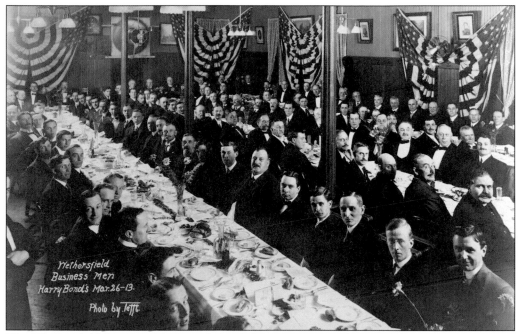

The Wethersfield Business Men's and Civic Association, seen here at a 1913 dinner meeting, founded Wethersfield Historical Society in 1932 in preparation for the 300th anniversary of the town in 1934. Three rooms in Center School (now the Keeney Memorial Cultural Center) were used to display historic objects and for meetings.

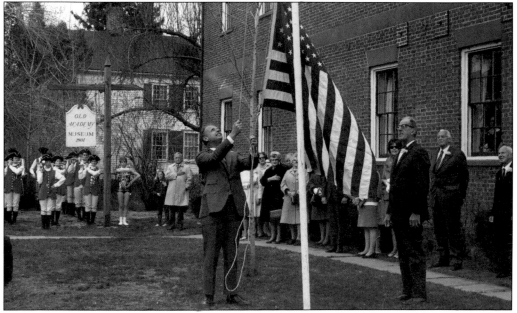

It was not until 1959 when the town and First School Society offered the use of the Old Academy that Wethersfield Historical Society had a permanent home. The society was originally operated by volunteers who conducted research, collected historic objects, mounted exhibitions, and offered public programs. This photograph shows the seasonal opening of the Old Academy in 1971.

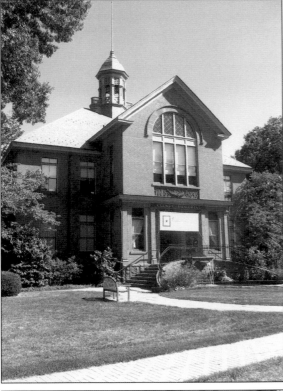

The Robert Allan Keeney Memorial Cultural Center, the flagship museum of Wethersfield Historical Society and Town Visitor Center, contains the society's exhibit galleries, public gathering rooms, and collections spaces. Built as the town's first high school in 1893, the building served as the junior high, elementary school, town court, library, and board of education before its latest incarnation as the Wethersfield Museum. The Fountain of Service, which honors the town's volunteers, was installed in 2000.

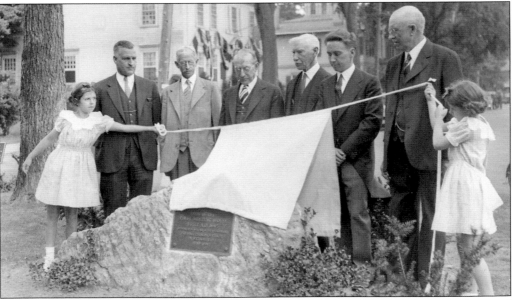

In 1934, Wethersfield celebrated its 300th anniversary, beginning with the unveiling and dedication of the Ten Adventurers boulder, which commemorates the first settlers of town. The 10 men who came to Wethersfield with John Oldham in 1634 to prepare for the arrival of their families the next year included Leonard Chester, Abraham Finch, Abraham Finch Jr., Daniel Finch, Nathaniel Foote, Robert Rose, Capt. Robert Seeley, Sgt. John Strickland, Andrew Ward, and John Clark.

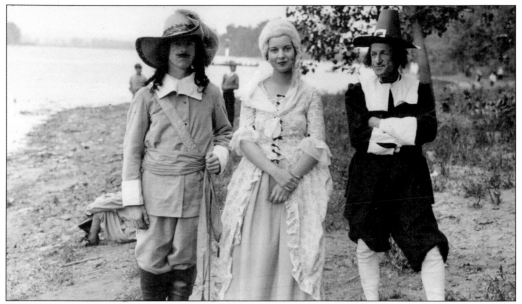

During the 300th anniversary, the pageant *Leaves of the Tree* was performed twice at Cove Park. The pageant included approximately 500 people from the four towns of Wethersfield, Glastonbury, Rocky Hill, and Newington, all originally part of Wethersfield. The three-hour pageant portrayed various people and events from Wethersfield's history. From left to right, Wethersfield residents J. Fales Popham, Gertrude Hanmer, and Harry Welles pose in their Colonial costumes at the Wethersfield Cove.

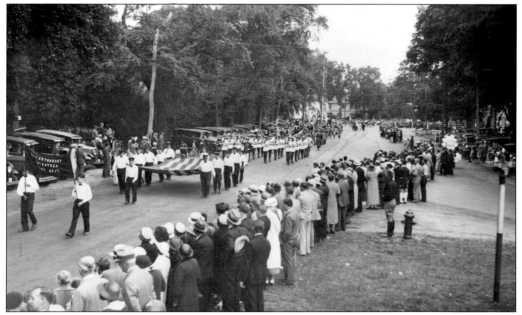

The tercentennial parade featured 5 bands, 10 drum corps, 19 floats, and 60 military and fraternal organizations from Wethersfield, Glastonbury, Rocky Hill, and Newington. The parade attracted 15,000 people, more than twice the entire population of town. Other activities during the 300th anniversary included an evening presentation of the Cove Warehouse to the park board and an illuminated motorboat parade.

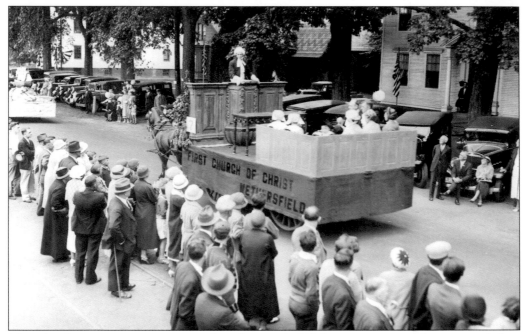

Many local organizations participated in the town's 300th anniversary celebration, including First Church of Christ. Its parade float featured the church's original pulpit, which was removed in the 1838 renovation of the church. The pulpit was reinstalled when the meetinghouse was restored to its Colonial appearance in 1973.

Jared Standish, the seventh generation of his family to live in Wethersfield, was a wood engraver, photograph engraver, and illustrator. Standish contributed to Henry Stiles's *History and Genealogy of Ancient Wethersfield*, published in 1904, and wrote many of his own articles and pamphlets on Wethersfield history. Standish designed the Wethersfield town seal, which features the Cove Warehouse, in 1928.

The Reverend John Marsh House, built in 1774, stood on Marsh Street near the cemetery grounds. This photograph from about 1892 shows the house before it was torn down in 1916. In response to the loss and alteration of buildings, residents, civic and historical organizations, and the town sought the preservation of its historical assets.

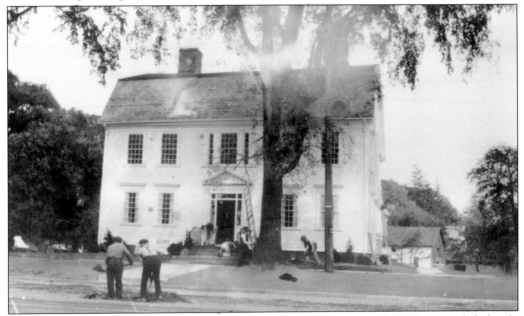

To save the Deming-Standish House, located in the center of the village, the Standish family gave it to the town in 1928 for preservation purposes. Leased to Wethersfield Bank and Trust, builder Albert G. Hubbard oversaw the restoration, which included removing porches, extending the rear of the first floor to accommodate the bank's vault, and adding a triangular pediment with eagle to the front door. (Courtesy of Richard B. Lasher.)

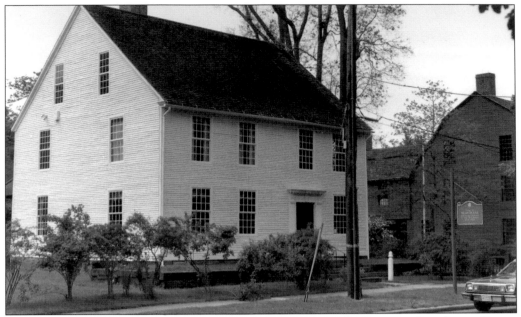

Silas Deane built his home on Main Street around 1766. During the American Revolution, Deane was secretary of Connecticut's committee of correspondence, a delegate to the Continental Congress, and helped plan and finance the capture of Fort Ticonderoga. By June 1776, he was in France secretly securing military supplies for the patriot cause. The nation's first diplomat, Deane was accused of mishandling funds and died before Congress cleared his name in 1830.

The Hurlbut-Dunham House at 212 Main Street was probably built in the 1790s, but the first documented owner was sea captain John Hurlbut, who was well known for circumnavigating the globe on the ship *Neptune* in 1800. The last owners, Jane and Howard Dunham, bequeathed the house and its contents to Wethersfield Historical Society. Now a museum, tours highlight the house's early-20th-century history.

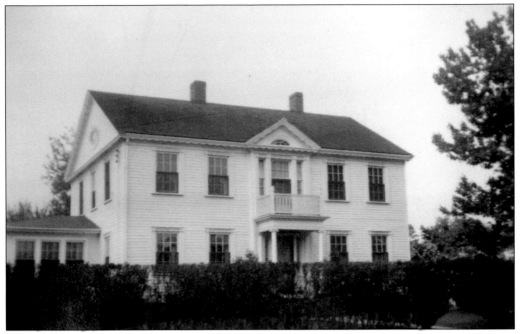

Edward Shepard, a skilled furniture maker and woodworker, built his house between 1807 and 1809. Intricate details of the house reveal his woodworking skills. The house originally stood on Main Street with Shepard's furniture shop located behind it, but it was moved around the block to 25 Church Street to accommodate changes in the village center.

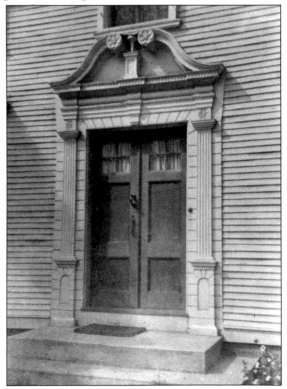

The Simeon Belden House at 251 Main Street features the only surviving example of a Connecticut River Valley doorway on its original location in Wethersfield. Developed during the mid-18th century, the doorway features a double door framed by fluted pilasters that support a series of moldings under an elaborate broken scroll pediment. These doorways express the wealth and status of the house owner.

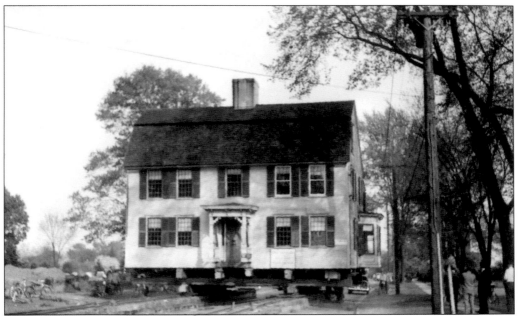

The Peter Burnham House, now at 36 Marsh Street, was originally built around 1757 and located across the street. The house was used as a parish house by the First Church of Christ for many years. When the church decided to build a new fellowship hall in the 1940s, it sold the Burnham House for $500. The buyer purchased the land across the street, where the house was moved on trailers.

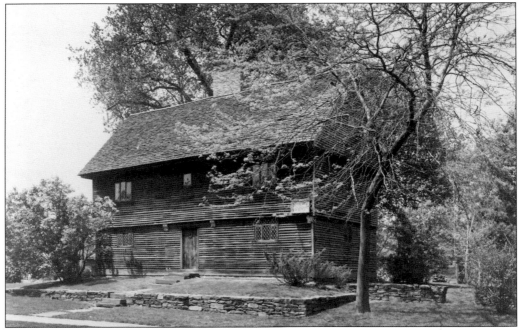

The Buttolph-Williams House, built on Broad Street around 1711, reflects the popularity of traditional English architecture in 18th-century Connecticut. The house was the setting for the Newbery Medal–winning book *The Witch of Blackbird Pond* by Elizabeth George Speare. Owned by Connecticut Landmarks, the Buttolph-Williams House is now a museum.

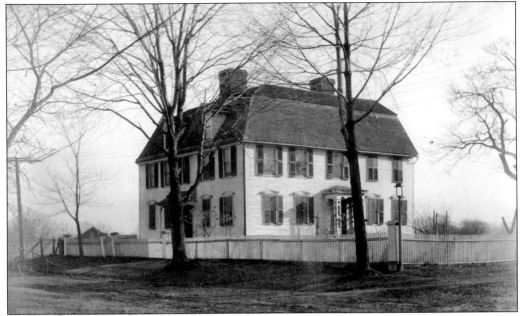

The original part of this house at 226 Broad Street was built in 1757. Sheriff Ezekiel Williams enlarged the house during the American Revolution, adding a two-story facade facing the Broad Street Green. Williams, a successful shipping merchant, was sheriff of Hartford County. In 1777, he was appointed deputy commissary of prisoners in Connecticut and was in charge of all prisoners of war in the state.

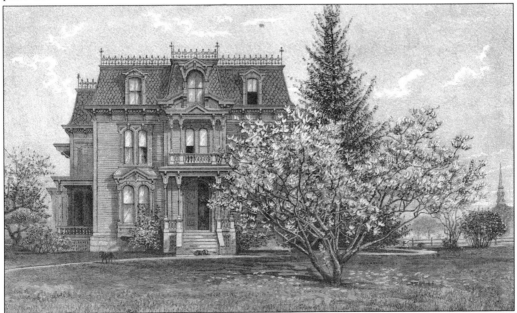

Wealthy businessman Silas Robbins built this Second Empire house at 85 Broad Street in 1878. Robbins operated a general store in Wethersfield and later became a partner of Johnson, Robbins and Company, one of the town's early seed companies. Robbins was also a banker, state senator, and town treasurer and postmaster. He was widely known for raising Jersey cows on his farm and exotic plants in his greenhouses.

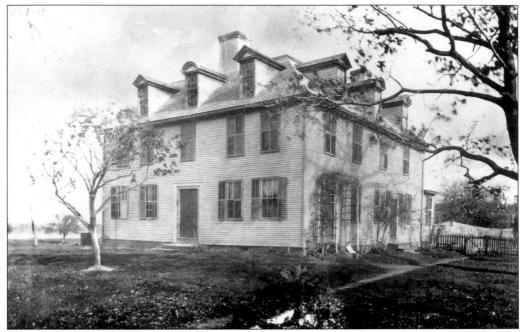

The Solomon Welles House was built overlooking the Wethersfield Cove in 1774. Situated next to the Connecticut State Prison, the state purchased the property in 1887 to serve as the home of the prison warden. When the prison closed in 1963, the house was given to the Town of Wethersfield.

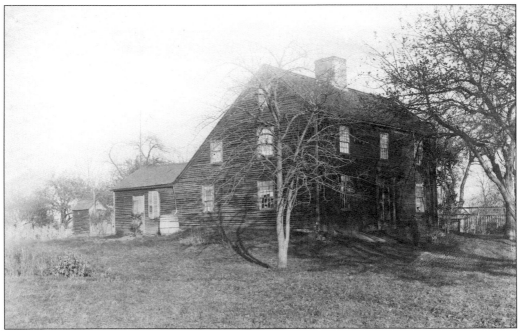

The earliest part of the Michael Griswold House was built in 1680 with the front of the house being added in 1730. The eight-room saltbox on Garden Street has always been lived in by members of the Griswold family. Today it is owned by the Griswold Family Association and is still occupied by Griswold descendants. (Courtesy of Richard Griswold.)

Historic homes are found throughout Wethersfield, not just in the historic district. This house from about 1750 at 62 Highland Street was built by Mr. North (possibly Isaac) as a wedding present for his daughter. This 1940s photograph shows the house before it was restored. (Courtesy of Julie Murtha.)

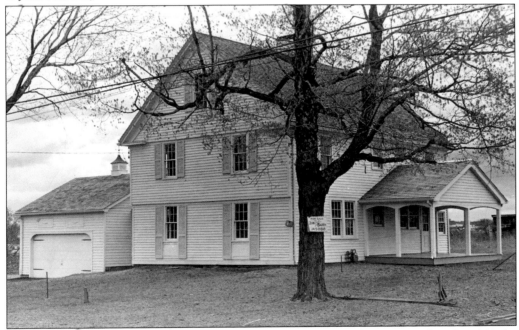

This house at the corner of Highland Street and Coppermill Road was restored in the 1960s by John Barry. Eventually an addition was also built, which is dramatically different from the before picture seen above. There has been a long tradition of Wethersfield residents lovingly restoring the town's important historic structures. (Courtesy of Julie Murtha.)

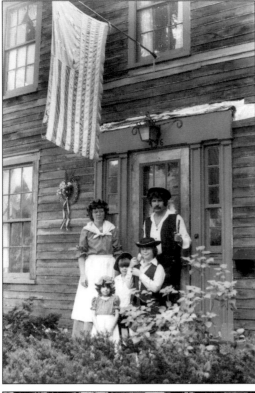

Wethersfield has always enjoyed celebrating history through parades, pageants, and festivals. The United States celebrated its 200th anniversary in 1976 with events throughout the country, including fireworks, nautical parades, reenactments, and other festivities. The Joseph family, Jean, Susan, Andrew, Bill, and Bud, pose in front of their house at 496 Main Street during the bicentennial celebration in Wethersfield. (Courtesy of Marilyn Ford.)

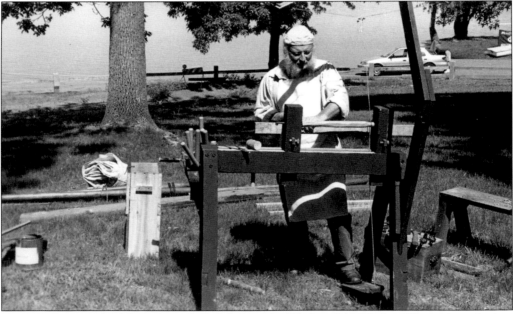

Later-day historical celebrations included the popular Wethersfield Weekend Festivals in the late 1990s and early 2000s. Part of the fun was "peopling" the historic sites with period craftsmen and historical reenactors who demonstrated early tools and skills. With a maritime theme on the embankment near the Cove Warehouse in 1999, reenactor Alex Kulchik demonstrates the fine art of woodworking with reproduction tools.

Five

THOSE WHO SERVED

As one of Connecticut's three founding towns, Wethersfield played an important role in the early governmental and military affairs of the colony. Connecticut's first military episode was the Pequot War of 1637. Having lived in Connecticut since 1600, the Pequot Indians feared the English establishing themselves in their territories. Between 1634 and the start of the war, the Pequots killed traders on the Connecticut River and raided Wethersfield. During the April 23, 1637, raid, the Pequots killed six men, three women, and 20 cows and carried off two girls. In response to the raid, the general court raised a troop of 90 men commanded by Capt. John Mason, who defeated the Pequots in a decisive battle on the Mystic River. Twenty-six men from Wethersfield served in the Pequot War, the beginning of the town's military history. Wethersfield residents served in other early military campaigns, including King Philip's War (1675–1676), King William's War (1689–1697), Queen Anne's War (1702–1713), King George's War (1744–1748), and the French and Indian War (1754–1763). About 100 Wethersfield men responded to the Lexington alarm, led by Capt. John Chester. By the end of the American Revolution, approximately 550 Wethersfield residents served the patriot cause. This tradition of military service continued into the 19th century and remains today. Wethersfield residents also served their town, state, and country through volunteering for the town fire department, working as police officers, and seeking political office.

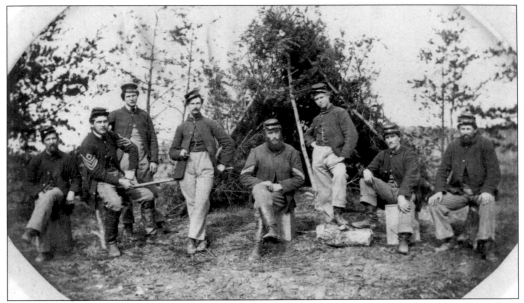

Approximately 200 soldiers are listed in the official Civil War Record of Service as residents from Wethersfield, which had a population of about 2,600 at the time. Wethersfield sent 193 soldiers to the Union army and only 3 to Pres. Abraham Lincoln's navy. In total, 13 were wounded, 11 discharged for disability, 36 deserted, and 22 died. The unit pictured above, the 22nd Connecticut Volunteers, contained the greatest number of Wethersfield recruits—41 in all.

During the Civil War, Sherman W. Adams (1836–1898), by appointment of Glastonbury-born Secretary of the Navy Gideon Welles, served in the U.S. Navy as acting assistant paymaster. He served aboard the gunboat USS *Somerset* on blockade duty in the Florida Gulf between 1862 and 1863. Adams returned to Wethersfield to practice law and write the town's history.

John Morris, a graduate of the Yale Theological
Seminary, mustered into the 8th Regiment of
Connecticut Volunteers as chaplain in 1862,
seeing action in Antietam. He resigned in
September 1863 and returned to Wethersfield
where he married Emily Augusta Griswold on
New Year's Eve in 1863. Morris served in the
Connecticut House of Representatives and Senate
as assistant clerk and clerk (1864–1866) and later
went south to assist in Reconstruction.

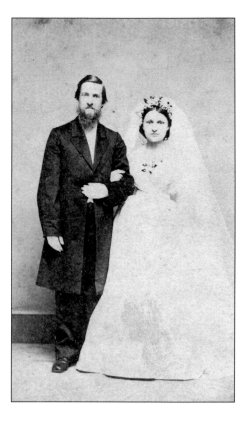

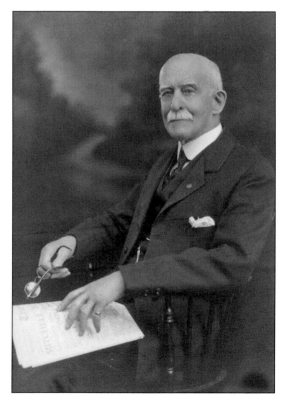

While serving with the 16th Connecticut
Volunteers, Sgt. Robert Kellogg was
captured by the Confederates at Plymouth,
North Carolina. After enduring nearly
a year of abuse, deprivation, and
near-starvation at Andersonville Prison
in Georgia, he was released, describing his
ordeal in *Life and Death in Rebel Prisons*. In
later years, he worked toward establishing
monuments for the 16th Connecticut
Volunteers, and he served as the model
for the statue of Andersonville Boy,
located just south of the capitol building
in Hartford.

The American Legion hall at the corner of Main Street and Hartford Avenue serves as a public gathering space for several organizations, including the Bourne-Keeney Post of the American Legion that meets the needs of the town's veterans. Originally built as a Baptist church, the second floor of the hall maintains the deck of the *Minerva*, training grounds for the town's Sea Scouts.

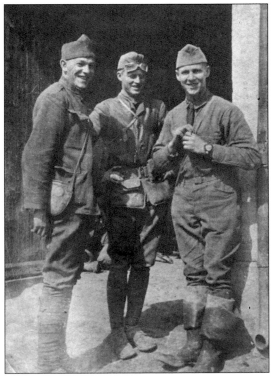

Everett H. Hart, seen on the right with two of his buddies, was a member of the 101st Machine Gun Battalion, 26th Division in World War I. Hart was one of 204 Wethersfield men who served during the war. Upon returning from service, Hart worked at Chas. C. Hart Seed Company, a family business, of which he became president.

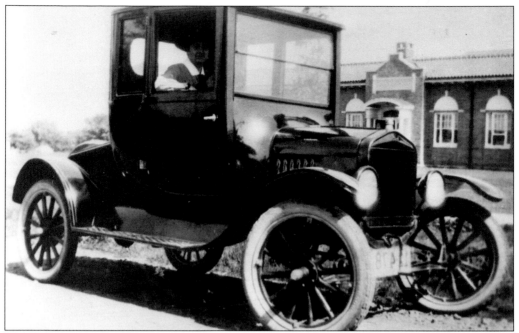

Elizabeth Holmes was hired as the school nurse for all Wethersfield schools in 1924. Much of her work involved public health issues and education. She monitored students for vaccinations against smallpox and typhus and assisted town physician Dr. Edward G. Fox in educating parents about family hygiene.

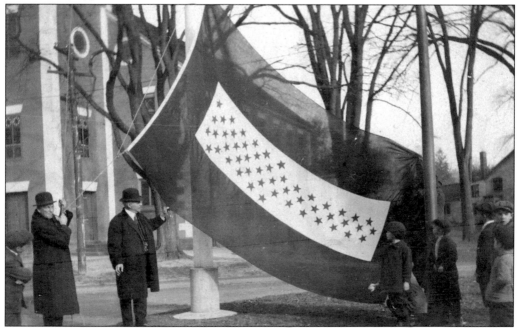

Beginning in 1917, service flags were seen in towns across the country. At home, families displayed small flags, with a blue star to denote someone on active duty or a gold star to reflect someone who died during service. In this World War I–era photograph, town officials raise a flag with stars most likely representing the current number of residents who were enlisted.

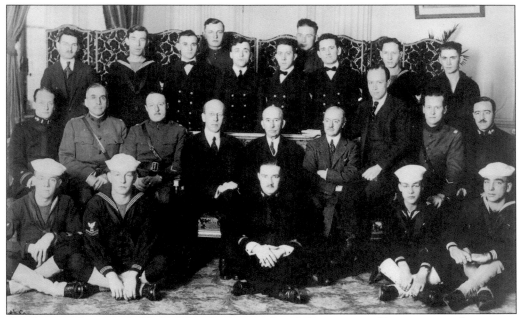

At the conclusion of World War I, thousands of American soldiers remained overseas to maintain the tenuous peace. During the American Peace Commission in Paris, from 1918 to 1919, this group photograph documented Wethersfield's Frederick Hale (seated on the floor, second from the left) serving as a navy representative in the honor guard for Pres. Woodrow Wilson. (Courtesy of Welles Hale.)

Assembling for a formal portrait, most likely during the Washington bicentennial or the tercentenary, Wethersfield's veterans of all wars pose in front of First Church of Christ. Sitting in the center of the group is the bearded Henry "Granpa" Lankton, the town's oldest living Civil War veteran. Lankton served as a member of the 22nd Connecticut Volunteers and lived well into the 1930s.

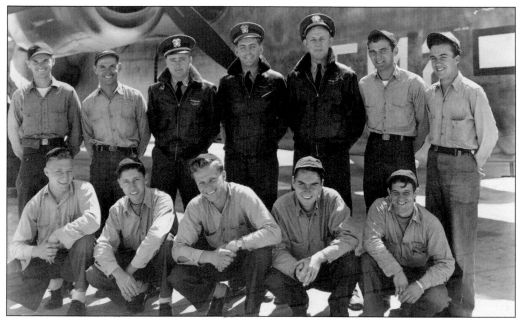

Naval air crewman George Wallace (front row, second from left) served in the Pacific aboard a Consolidated PB4Y2 Patrol Bomber in San Diego. His crew consisted of three officers and eight enlisted men who maintained and flew land-based navy planes for surveillance. He served more than two and a half years in the Pacific, logging approximately 500 flight hours. (Courtesy of George Wallace.)

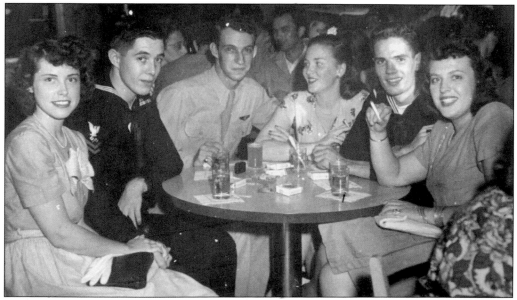

All from Wethersfield, three servicemen on leave and their lady friends socialize at East Hartford Town Hall on August 11, 1945. Pictured from left to right are unidentified, Stephen Hart, Perry Cornwall, Jean Blease May, Tom Tryon, and Sue Warmer. Tryon achieved success as a Hollywood actor and later author; many of his novels are based in fictionalized Wethersfield. He was nominated for a Golden Globe for his title role in 1963's *The Cardinal*. (Courtesy of Perry and Marilyn Cornwall, and Johnnie Hart.)

In World War II, Americans were asked to make personal sacrifices, to live with less, so that precious resources could support the armed services. On the home front, Wethersfield's war council met at the Welles building (now the Keeney Center) overseeing operations such as the Exchange Club and the town's local price ration board, pictured above. It monitored the allotment given to each of its citizens, striving for fairness when most people were in restricted circumstances.

Robert Allan Keeney, who grew up in Wethersfield, enlisted in the navy while a sophomore at Wesleyan University in Middletown as part of the navy's V-12 recruitment program. He attended midshipman school at Cornell University, receiving his ensign's commission in 1944. At age 21, Keeney was among the 1,196 men killed aboard the USS *Indianapolis* when it was hit by three torpedoes from a Japanese submarine on July 30, 1945.

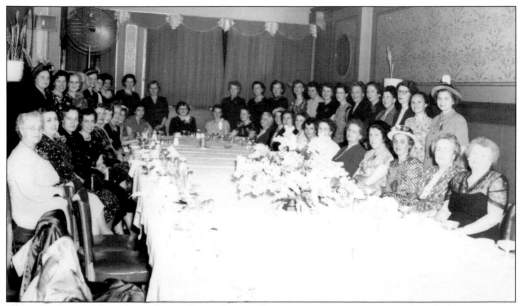

The Wethersfield and Rocky Hill Professional Nurses Association was founded in 1941 in response to the need for nursing volunteers during World War II. Nurses volunteered at area hospitals and in the community. Today the association administers vaccines, awards scholarships, provides educational programs, and loans medical equipment to those in need. This photograph shows the annual banquet of the association in 1949. (Courtesy of Wethersfield/Rocky Hill Professional Nurse's Association.)

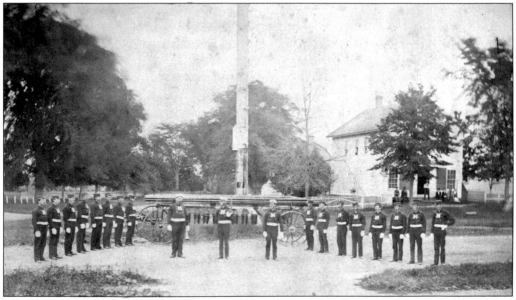

The Wethersfield Volunteer Fire Department was chartered by the State of Connecticut in 1803, which establishes it as the oldest volunteer department in continuous existence in New England. With two devastating Main Street fires in 1831 and 1834, the department moved beyond the bucket brigade and invested in progressively sophisticated fire machinery, equipment, and training. The department's 1870s ladder carrier and Hope One Company assembled at the intersection of Main and Marsh Streets for this photograph.

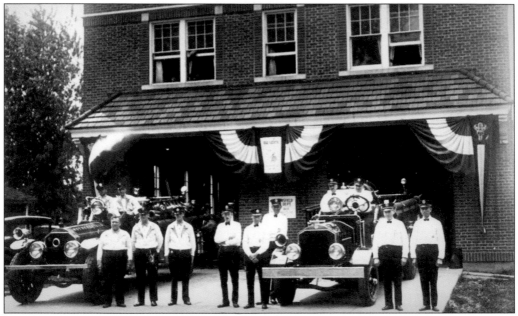

By 1913, the town's fire company had reorganized, becoming Wethersfield Fire Company No. 1. To keep pace with the growing town and increasingly professional techniques, the firehouse was built in 1923. This structure was later replaced by the present firehouse. The company sported its new uniforms for the Washington bicentennial in 1932. (Courtesy of Wethersfield Volunteer Fire Department.)

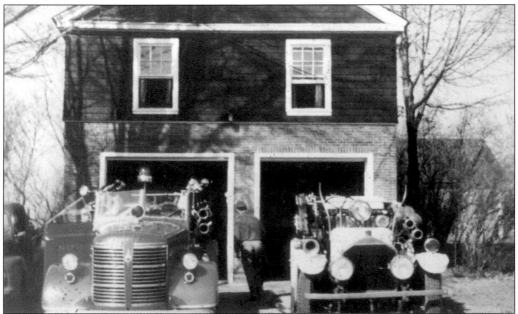

Wethersfield's early-20th-century growth prompted the fire department's expansion to two companies. Griswoldville founded its own company in 1925 to serve the needs of the southern end of town. Its first firehouse, located across the street from the Griswoldville Chapel, included a brick first floor for the trucks and incorporated the former Griswoldville wooden one-room schoolhouse as its second floor. (Courtesy of Wethersfield Volunteer Fire Department.)

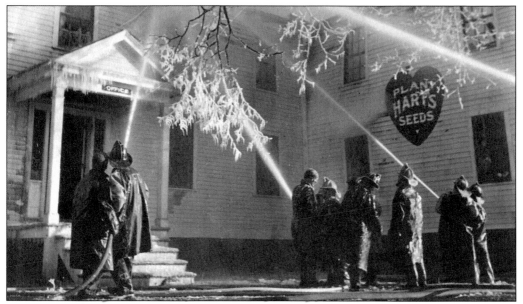

The main building of Chas. C. Hart Seed Company caught fire in the winter of 1943. Battling the subzero temperatures and low water pressures common to the colder months, the department extinguished the blaze and the business rebuilt on the site. In addition to fighting fires, the department served many functions in the community, including assisting with recovery efforts in the 1936 flood and 1938 hurricane, operating the civil defense program during the cold war, and quelling riots at the prison. (Courtesy of Wethersfield Volunteer Fire Department.)

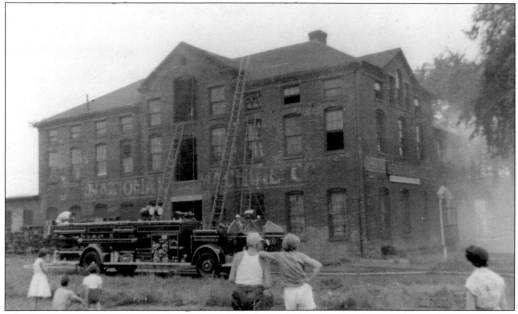

The fire department successfully extinguished the 1952 blaze at the Gra-Rock Bottling Company. Located near the growing commercial development on the Silas Deane Highway, the structure demanded the improved equipment from the ever-expanding department. A former tenant of the building included Bailey Manufacturing, and the structure presently houses the Clearing House Auction Galleries. (Courtesy of Wethersfield Volunteer Fire Department.)

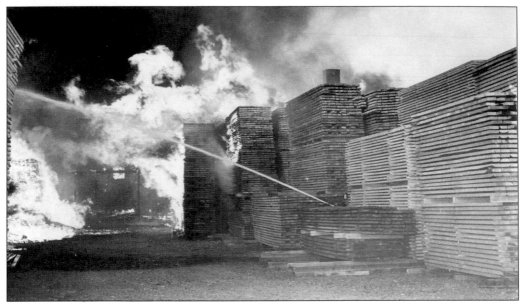

The largest fire in the town's history occurred at the Wethersfield Lumber Yard in 1955. Resulting in a total loss, the spectacular blaze shut down adjoining thoroughfares Silas Deane Highway, Jordan Lane, and nearby Routes 5 and 15. With the opening of Interstate 91 in the 1960s and the exponential growth during the town's postwar housing boom, the department kept pace by founding company No. 3 in 1957 on Kelleher Court. (Courtesy of Wethersfield Fire Department.)

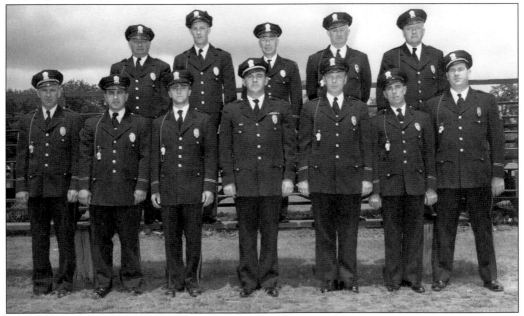

Wethersfield Police Department began in 1926 with the establishment of a police commission and the appointment of four constables to manage traffic. Six more "supernumaries" were added in 1936, and the department was housed in successive locations, including the Old Academy (former town hall), the Little Red Schoolhouse, and the Deming-Standish House. Chief Tom Sullivan, center, is assembled with his officers on Memorial Day in 1952.

In the 1930s, the Wethersfield Police Department had two official police vehicles, a motorcycle usually used by Chief William G. Simpson and a 1938 Ford. Policeman Robert H. Hungerford poses around 1937 with the one department motorcycle. Hungerford rode the motorcycle in the opening ceremony of the Middletown-Portland Bridge. (Courtesy of Janet Coates.)

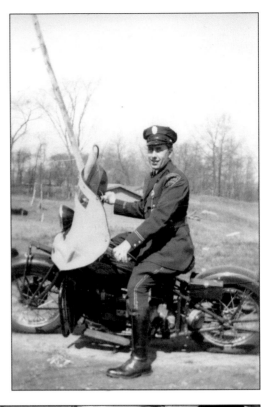

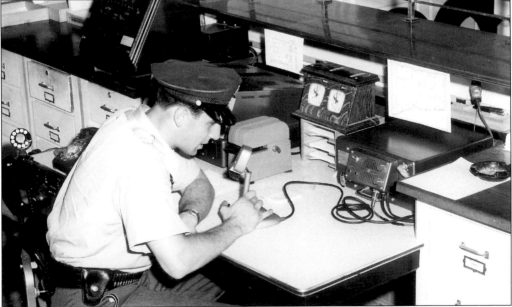

Until the late 1940s, the Hartford Police Department provided radio dispatching services to most nearby suburban police departments. Wethersfield monitored the Hartford broadcasts but could not communicate with dispatchers until the department acquired FM two-way radios in 1949. In 1955, Wethersfield had its own central dispatch system for police and fire that was staffed 24 hours a day, seven days a week. (Courtesy of Wethersfield Police Department.)

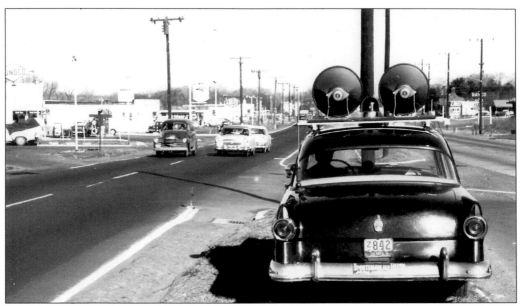

A portion of the Berlin Turnpike, an early north–south route between New Haven and Hartford, runs through Wethersfield. Similar to the Silas Deane Highway, this busy commercial strip required increased policing, especially during the incredible postwar boom. This manned police cruiser with enormous speakers sits facing north on the turnpike at the intersection with Arrow Road, the only traffic light along this Wethersfield strip at the time. (Courtesy of Wethersfield Police Department.)

Perhaps writing a ticket for speeding, this 1940s police officer serves as a member of the small force of 10 "supernumaries," one full-time officer, and the chief, who maintained order in a population of 15,000 by the end of the decade. Paralleling the growth of the town, the police department increased in professionalism, training, and sophisticated law-enforcement technology, moving into its improved town hall headquarters in 1960 and later to its own building in 2003. (Courtesy of Wethersfield Police Department.)

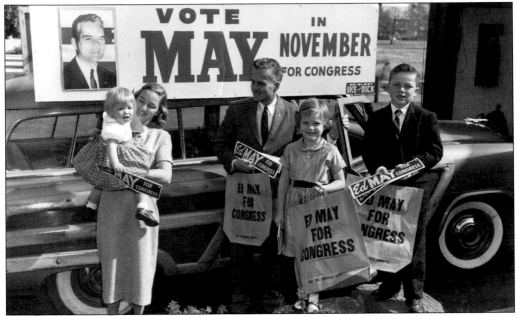

After graduating from Wethersfield High School in 1942, Edwin May attended Wesleyan University but left to serve as a lieutenant and P-38 fighter pilot during World War II. He returned to Wesleyan after the war and received his degree in 1948. May worked in the insurance industry and pursued a political career. In this photograph, May and his family, from left to right, Lisa, Jean, Ed, Laura, and Ted, campaign in the 1950s. (Courtesy of Debbie May.)

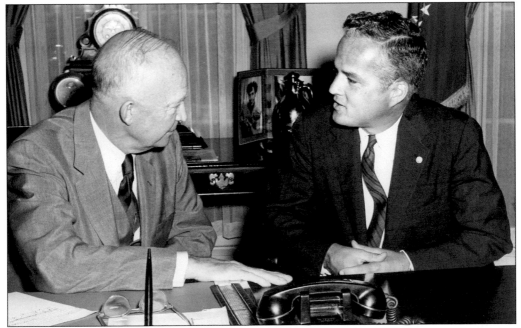

After World War II, May worked in the insurance industry, and in 1952, he was cofounder of the Insurance City Open Golf Tournament, which later became the Greater Hartford Open. In 1956, he was elected to the 85th Congress, the youngest member to serve in that year. Here he is seen with Pres. Dwight D. Eisenhower around 1958.

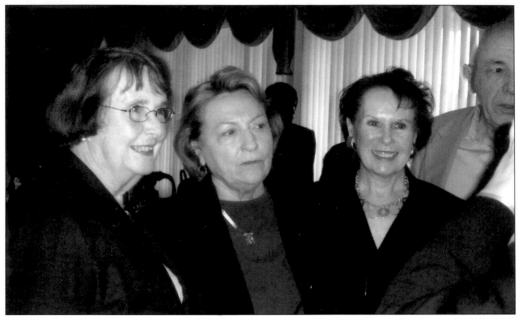

On the Democratic side, longtime U.S. congresswoman Barbara Kennelly (center), although not from town, represented several communities, including Wethersfield, while serving from 1982 to 1999. Here she congratulates probate court judge Sheila Hennessey (left) on her many years of service at her retirement brunch. Also pictured are longtime Democratic supporters Shirley Steinmetz and Joe Coombs (right). (Courtesy of Shirley Steinmetz.)

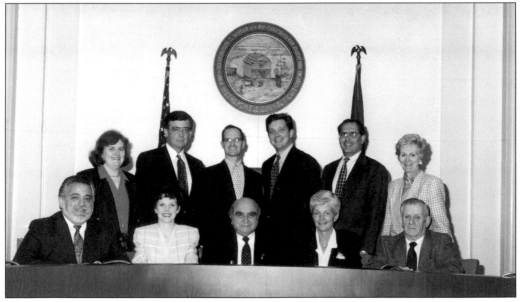

Wethersfield adopted a town council/town manager form of government in 1954. Council members serve their town as volunteers. The 1993–1995 town council includes, from left to right, (first row) Dick Sparveri, Cathy Mohan-Hallisey, Mayor Dan Camilliere, Deputy Mayor Judy Parker, and Jack O'Leary; (second row) Gerri Roberts, Wayne Sassano, Tom Curtin, Ron Zdrojeski, town manager Lee Erdmann, and town clerk Dorcas McHugh. (Courtesy of Gerri Roberts.)

Six

A COMMUNITY OF FAITH AND EDUCATION

Before 1818, the Congregational Church was the established church in Connecticut, although the Anglicans were allowed to organize in 1727, the Quakers and Baptists in 1729, and the Presbyterians in 1743. In the 19th century, other religious denominations began to establish churches in Wethersfield, creating a more diverse religious community. The introduction of denominations such as the Roman Catholic Church reflected the changing population of Wethersfield at the dawn of the 19th century. Other organizations besides houses of worship reflected Wethersfield's population changes, particularly its schools. Wethersfield hired its first schoolmaster in 1650, just 16 years after its founding. The first school was located on Main Street, and a second schoolhouse was built in 1663. In the late 18th century, wooden schools were replaced by brick buildings. These one-room brick schoolhouses in six districts served until the early 20th century, when suburban growth provided a tax base for new schools. The development of Wethersfield in the early 20th century led to an increase in population and the need for new schools. Five new schools were erected between 1917 and 1930. The first school buses were used in 1924, and free textbooks were provided beginning in 1925. Between 1950 and 1960, Wethersfield's population increased 64 percent, leading to more schools being built. A decrease in school population in the late 1970s and early 1980s led to the closing of some of these schools, which had faithfully served the youth of the community.

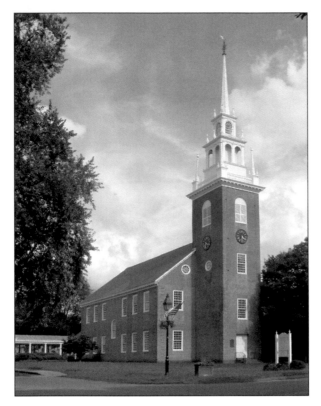

Wethersfield's First Church of Christ was founded in 1635. Its current building, erected between 1761 and 1764, is one of only three Colonial meetinghouses still standing in Connecticut and the only one made of brick. The meetinghouse was renovated in 1838 and 1882 but was restored to its original appearance in 1973. (Photograph by Laurie Hart; courtesy of First Church of Christ.)

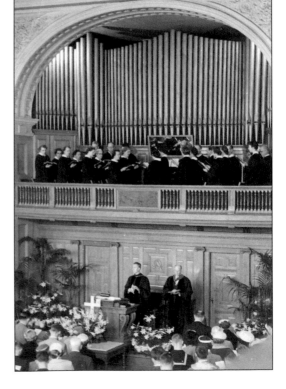

Rev. Keith Jones, left, conducts Easter services at First Church of Christ in the late 1940s. Jones served as minister of First Church for 35 years, from 1943 until his retirement in 1978. The interior of the church, as seen in this photograph, still retained its Victorian decoration from the 1880s renovations. Jones headed the Colonial restoration of the church in the early 1970s. (Courtesy of Barbara McLean.)

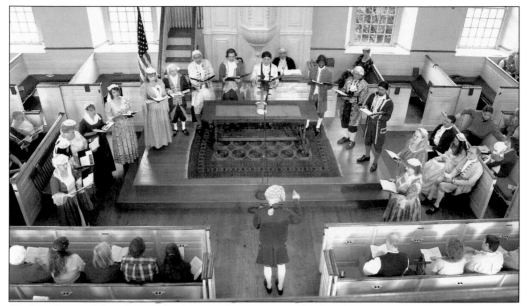

Gathered in 1635 and now the largest Congregational Church in New England, First Church connects its past with its future. Restored to its original 1761 appearance in the 1970s, the church hosts a full program of musical events and programs in addition to its outreach and educational ministries. Among the most popular events are concerts, which often include professional organists, hand-bell choirs, or costumed performances. (Photograph by Laurie Hart; courtesy of First Church of Christ.)

The Wethersfield United Methodist Church began in 1790 when Rev. Jesse Lee preached at North Brick School. Services were held in the Old Academy until 1824, when the cornerstone for the first Methodist house was laid at 130 Main Street. In 1882, the tower and spire were added, and windows were replaced with cathedral glass. (Courtesy of Temple Beth Torah.)

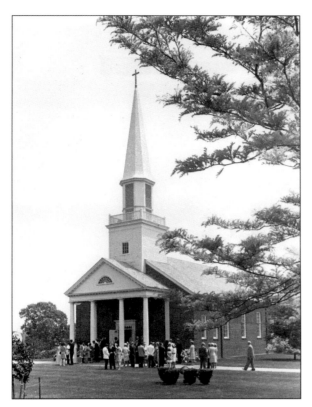

The congregation of Wethersfield United Methodist Church voted to relocate the church, as it outgrew its Main Street location. In 1958, groundbreaking at a new site on the corner of Prospect Street and Millwoods Road began, and in 1959, the building was completed and consecrated. (Courtesy of Wethersfield United Methodist Church.)

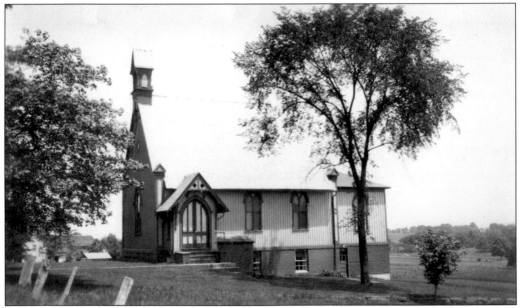

In 1860, the Griswoldville Union Sunday School began in the home of Thomas Griswold, where residents met to discuss how to meet the religious needs of Wethersfield residents who were cut off from the center of town due to poor roads. The first session of the Sunday school was held in the Little Red Schoolhouse. In 1872, the Griswoldville Chapel was built for the Sunday school.

The chapel served as the spiritual and emotional center of Griswoldville. In addition to religious services and education programs, it provided community meeting spaces and a location for official and ceremonial gatherings. Here young people eager to escape from the chapel's confines in the 1950s head for less-edifying pursuits. (Courtesy of Griswoldville Chapel.)

Griswoldville residents maintain local pride in their section of town, distinct from parts of greater Wethersfield and fairly rural until the mid-20th century. Mugging for the camera in front of the chapel around 1935, these grinning boys came of age just in time to serve their country in World War II. They are, from left to right, Bill Herold, Bill Tribou, Myron Baldwin, Ira Hart, John Heath, and Edgar Mack. (Courtesy of Griswoldville Chapel.)

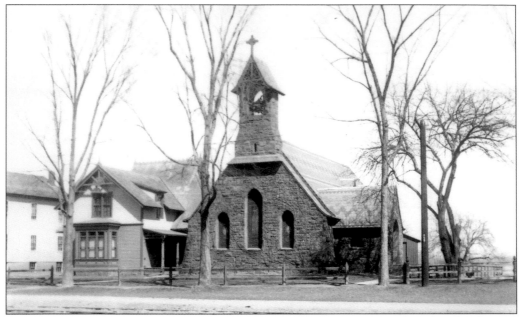

Trinity Episcopal Church began in 1868 as a mission sponsored by the Church of Good Shepherd in Hartford. In 1871, the newly formed parish laid the cornerstone of its church on Main Street. The building was not completed until 1874 due to financial difficulties. Hartford resident Elizabeth Colt, widow of gun manufacturer Samuel Colt, was one of the people who came to the financial rescue of the church.

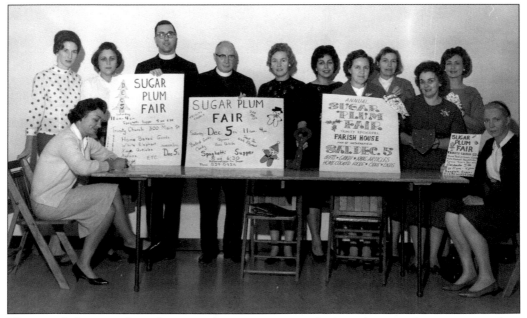

The town's houses of worship served as important gathering places to form or strengthen community bonds and social networks. Working together in outreach ministries, educational projects, or fund-raisers, such as the Sugar Plum Fair at Trinity Episcopal Church, provided people opportunities to further the work of the parish while caring for the needs of the surrounding community. (Courtesy of Trinity Episcopal Church.)

In 1876, Rev. Lawrence Walsh, pastor of St. Peter's Church in Hartford, organized the first Roman Catholic Church in Wethersfield. In 1880, Sacred Heart Parish, as seen in this photograph, was built on Garden Street. A growing membership led to the purchase of the Meggat seed warehouse on Hartford Avenue, which was converted into a church in 1924. The former church building was used for religious education programs.

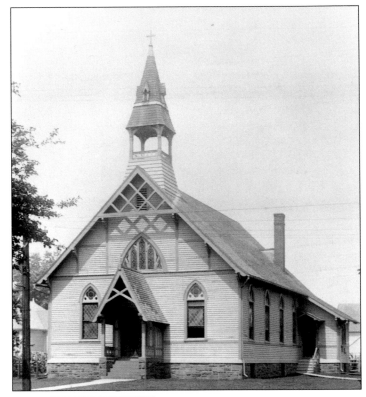

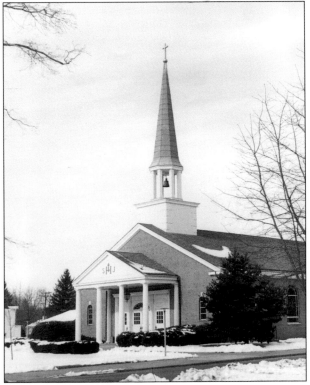

The warehouse church served Sacred Heart Parish until 1962, although between 1938 and 1943, the parish reoccupied the original Garden Street church due to extensive fire damage at the warehouse. In 1962, Sacred Heart Parish erected a new church on Hartford Avenue to avoid costly repairs to the aging Meggat seed building. The former Meggat residence serves as the rectory.

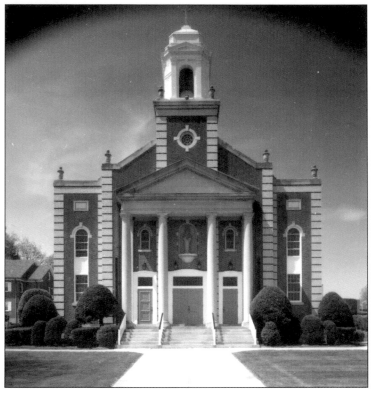

In 1939, the newly built Roman Catholic church on the Silas Deane Highway was dedicated as Corpus Christi. It was built as a mission church of Sacred Heart because of a growing Catholic population due in large part to the recent migration of Irish, Italian, and Polish immigrants from Hartford. The church was purposely built in the style of Georgian Colonial in recognition of the historic and Colonial background of Wethersfield.

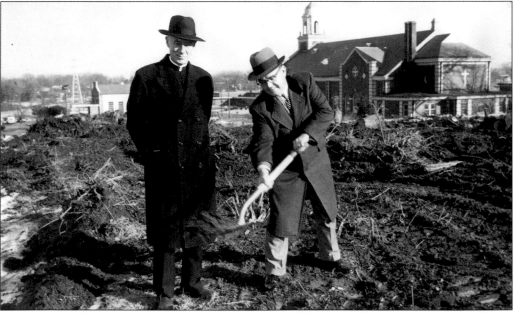

Fr. Francis Nash, seen on the left in this photograph of the groundbreaking for Corpus Christi School in January 1960, encouraged parishioners to build a parochial school to meet the education needs of the large Catholic population in Wethersfield. The school, located on the Silas Deane Highway, educates children from nursery school through eighth grade. (Courtesy of Corpus Christi Church.)

The Church of the Incarnation was established in 1963 out of necessity to redistribute the population of Corpus Christi Church. Masses were held at Samuel Webb Junior High School until the new church on Prospect Street was completed in 1965. The modern church was built in the form of a crucifix with a 50-foot cross located in front of the main entrance and contains stained-glass windows depicting scenes from the town's history.

Wethersfield Evangelical Free Church began in 1888 as a missionary parish to Danish people of Hartford. The congregation met in private homes and other locations within Hartford until 1961 when a new church on Maple Street in Wethersfield was completed. This 1988 photograph shows the congregation celebrating its centennial.

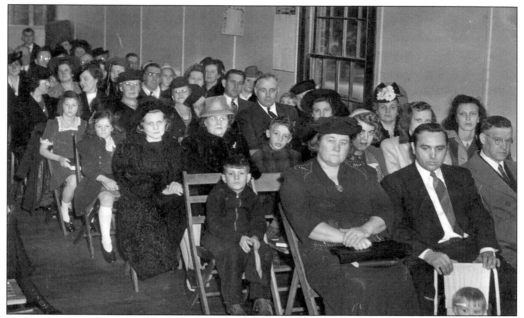

In 1942, the first services of St. Paul's Evangelical Lutheran Church, as seen in this photograph, were held in a vacant store at 689 Wolcott Hill Road. A mission congregation of 33 people gathered to form the church, which eventually worshiped in the first floor of a house at 371 Wolcott Hill Road that also served as the home of the congregation's first pastor. (Courtesy of the Doerschler family.)

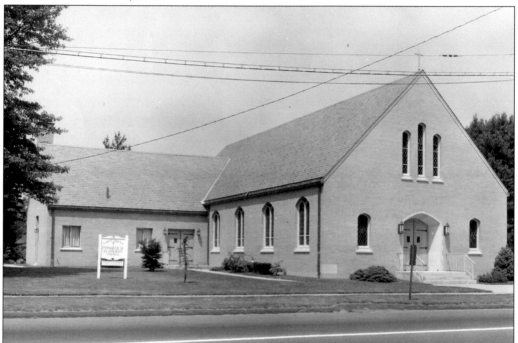

St. Paul's Evangelical Lutheran Church built its current church in 1957, holding its first service on New Year's Day in 1958. The church eventually added a parish education building in 1965 and a fellowship hall in 1996. (Courtesy of the Doerschler family.)

In 1960, Temple Beth Torah acquired the former Methodist church on Main Street, which it significantly altered to meet its needs as a synagogue. Temple Beth Torah's Day of Dedication took place on May 28, 1961. Bringing in the Torah to celebrate the occasion, from left to right, are Herbert Slotnick, Dr. Alvin Carlin, Leslie Birnbaum, an unidentified guest rabbi, Gerald Berg, another unidentified guest rabbi, and David Taulin. (Courtesy of Temple Beth Torah.)

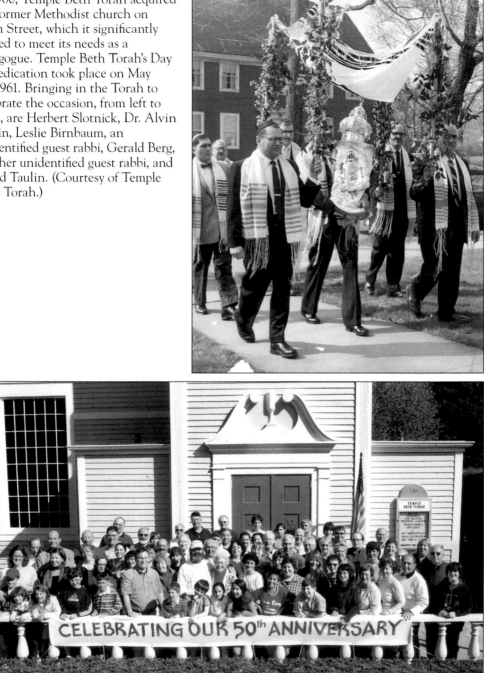

In 1954, 18 families convened to form the Jewish Community Group of Wethersfield. Between 1954 and 1960, meetings, services, and educational events were held in a variety of borrowed locations. In 1960, they adopted the organizational name of Temple Beth Torah. In September of that same year, they acquired the former Methodist church at 130 Main Street. Synagogue members celebrated their 50th anniversary in 2004. (Photograph by Steve Dunn; courtesy of Temple Beth Torah.)

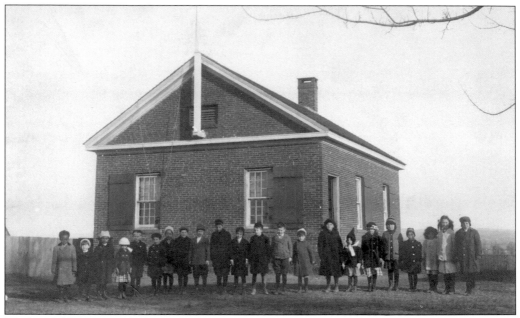

Wethersfield separated the town into six school districts, including North, West Hill, Griswoldville, High Street, Broad Street, and South Hill, to serve the educational needs of its children. In the 18th century, several brick school buildings, including South Hill School seen in this photograph, were erected to take the place of older wooden structures. These new brick, one-room schoolhouses were very similar in style, reflecting a uniform approach to education.

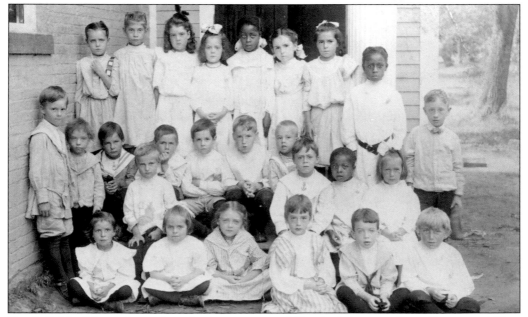

North Brick School, located at the intersection of Hartford Avenue, State Street, and Nott Street, served the community for nearly 150 years before closing around 1924. One of the brick schools erected in the 1770s, the school was altered several times over the years, including the addition of a bell tower, which has since been incorporated into a private home. This photograph from about 1915 shows one of the last classes to experience one-room-school education.

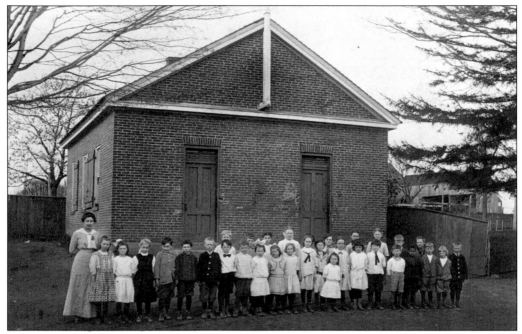

In 1835, Wethersfield divided the West Hill District, adding the Griswoldville District. The Griswoldville School was built of wood in 1837 and was replaced by a brick building in 1852. This 1920 class photograph shows the teacher and students standing in front of their school. Note the two entrances, one for the boys and one for the girls. (Courtesy of Jim Peruta.)

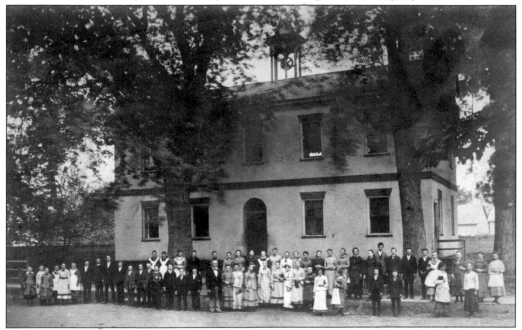

In 1804, the First School Society built the Old Academy, a school and meeting hall. The Old Academy had two rooms on the first floor and a large room on the second floor for public meetings. The first schools were private institutions. The most successful was the female seminary conducted by Joseph Emerson, a pioneer in the field of higher education for women.

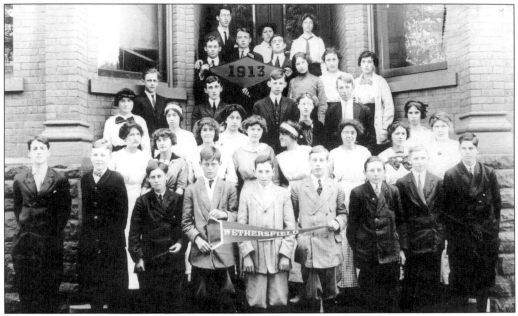

In 1839, the First School Society voted to establish a public school of higher learning but was not initially successful. In 1867, Chauncey Rose, a Wethersfield native who moved to Indiana, gave the society $6,000 to be used for a high school. In 1868, a school was started at the Old Academy and continued until 1894 when the Gov. Thomas Welles School was opened. The class of 1913 poses in front of the school.

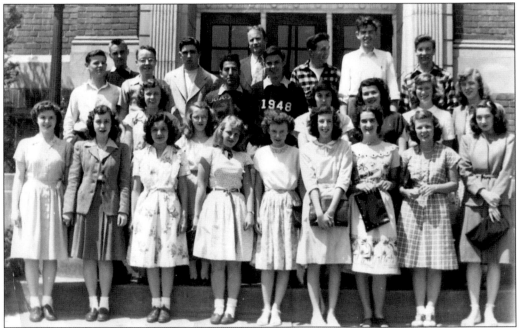

By the 1930s, the town had outgrown its high school and a new one was built on the Silas Deane Highway, approximately where the middle school is today. The high school served the student population, such as this smiling group of 1948 bobby-soxers, until 1954 when the new one was built on Wolcott Hill Road. (Courtesy of George Clark.)

Social occasions such as pep rallies, field trips, sports games, and dances allowed some welcome relief from textbooks and classroom studies. Full tulle skirts and white tuxedo jackets befitted these two smart couples at Wethersfield High School's senior ball in 1955. Pictured from left to right are Carol Wilkes Hughes; Garret Hughes; Aldea Kess; and Dave Reader. (Courtesy of Carol and Gary Hughes.)

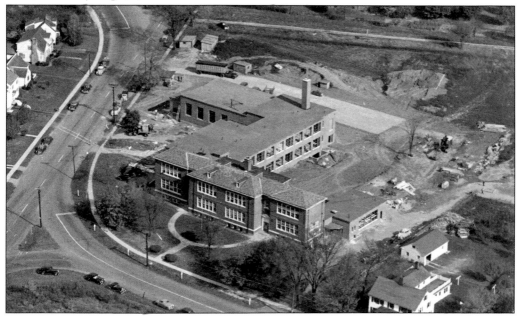

An increase in population in Wethersfield in the early 20th century led to the need for new schools. Charles Wright School was built in 1917, Stephen Mix Mitchell School in 1922, Francis-Stillman School in 1924, a new high school in 1929, and Col. John Chester School in 1930. Although it started as a four-room school, this aerial photograph shows Stephen Mix Mitchell School, as it appeared in 1951 after several expansions.

Members of the Wethersfield community take part in the groundbreaking for Hanmer School in 1966. Pictured from left to right are (first row) Cynthia Clancy, Alfred Welles Hanmer III, and David Clancy; (second row) Mayor M. Peter Barry, chairman of the school building committee Archer B. Hamilton, Pauline Clancy, and chairman of the board of education Richard Ellis. (Courtesy of Polly Clancy.)

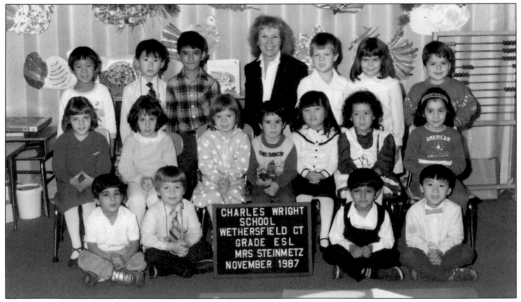

Repeating the immigration pattern in later years, new arrivals to town brought different ethnic and cultural identities, including African American, Hispanic, Eastern European, Indian, Asian, and many more. The town's school system rose to the challenge to educate its young people with diverse backgrounds. More than a dozen different ethnicities are reflected in Shirley Steinmetz's first English as a second language class at Charles Wright Elementary School in 1987. (Courtesy of Shirley Steinmetz and the Wethersfield Public Schools.)

Seven

WETHERSFIELD REMEMBERS

Wethersfield has a strong sense of community, shaped by its many active clubs and organizations. Residents gathered at places of worship and schools that served as social centers, providing space for recreational activities such as lectures and dances. Clubs often combined business and pleasure and offered members an escape from the routines of daily life. Participating in sports, a part of American life since the Colonial era, was a popular leisure activity. Fraternal organizations and ladies' societies, some founded as part of national organizations, were common in the 19th century and remain active into the 21st. Newer clubs are often more casual than earlier organizations, sponsoring activities such as fairs, dances, picnics, and concerts, providing social activities for members. Many groups combined recreational pursuits and civic responsibility that benefited their members and the community. Wethersfield is proud of its founding role in the Greater Hartford Open golf tournament and its Red Onion, which has become the mascot of this historic town. With this strong community identity, Wethersfield has been able to handle any crisis, from natural disaster and beyond. The town pulled together to recover from the flood of 1936 and, following the 9/11 tragedy, community involvement helped the town to heal by honoring those it lost. Historic photographs, while documenting the past, help Wethersfield to remember.

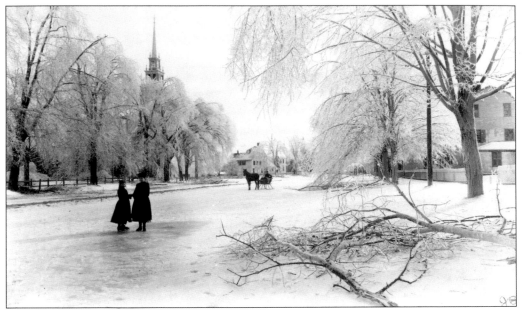

This photograph of an 1880s ice storm shows the center of Wethersfield village. Natural disasters are part of every community's history, including Wethersfield. This photograph suggests that residents dealt with such issues with remarkable spirit, as the one woman appears to be on ice-skates. The spire on the left is First Church of Christ, with the post office and Standish General Store beyond it.

In this photograph, Judy Libby is seen sledding on Burbank Road in December 1938. The Connecticut River, as seen in the background, is still accessible. In the 1960s, Interstate 91 was built on a raised roadway through the Great Meadows, cutting off Wethersfield and its cove from the Connecticut River. (Courtesy of Judy Libby.)

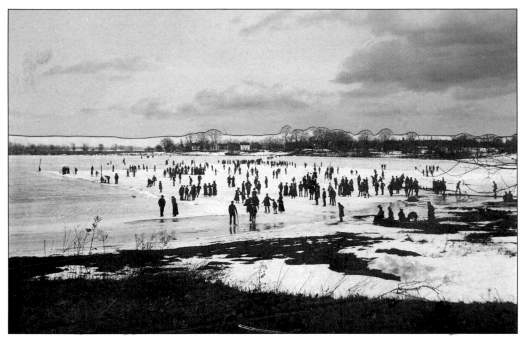

In the 19th century, America's notion of free time changed, and all social and economic classes began to pursue leisure activities. The Wethersfield Cove was a popular recreational spot in town, attracting many for social and athletic activities, including ice-skating in the winter. At the time, eager participants strapped on skates over their existing shoes.

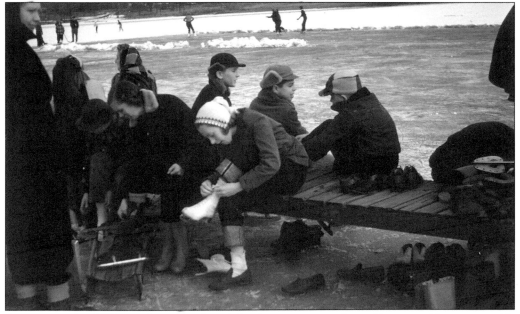

America in the 1950s can be remembered for the space race, the cold war, and large cars with tail fins. Regardless of the rapid cultural changes, some Wethersfield children still enjoyed old-fashioned fun. Young Meg Macdonough concentrates as she laces up her skates to brave the natural skating rink on the frozen surface of Wethersfield Cove in 1954. (Courtesy of Margaret Macdonough.)

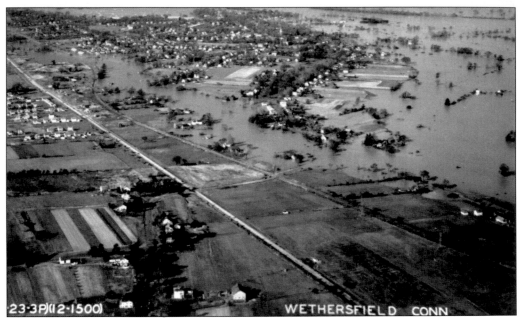

In 1936, the worst flood in Connecticut's history hit the community of Wethersfield. Melting ice and snow in Vermont and New Hampshire and days of rain led to the Connecticut River overflowing its banks in March 1936. Three-quarters of Wethersfield east of the Silas Deane Highway was underwater. This aerial photograph shows how old Wethersfield at the top of the image became an island during this devastating flood. (Courtesy of Phil Lohman.)

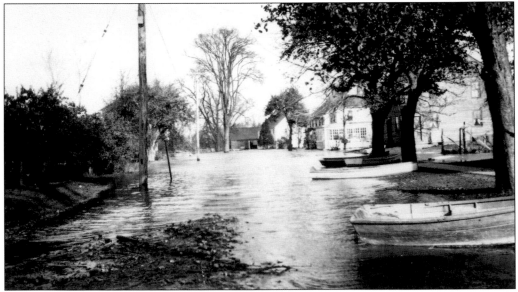

Located near the Wethersfield Cove, the northern end of Main Street, as seen in this photograph, was one of the first areas to flood. By March 19, 1936, the high-water mark of 30 feet from 1927 had been surpassed. Water covered the first floors, and families either left their homes or moved to their second floors. Members of the Russell K. Bourne Post of the American Legion were the first on duty to help stranded residents.

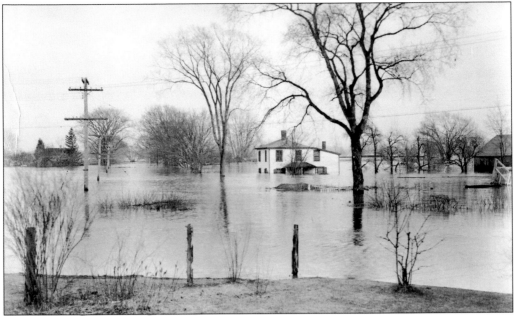

This photograph shows Marsh Street and the corner of Broad Street looking east during the flood of 1936. Many organizations pitched in to help during this devastating natural disaster. Legion Hall served as relief headquarters. Refugees found shelter at First Church, where women of the Church of the Sacred Heart, the Women's Association, and the Methodist Church served meals to 200 people a day.

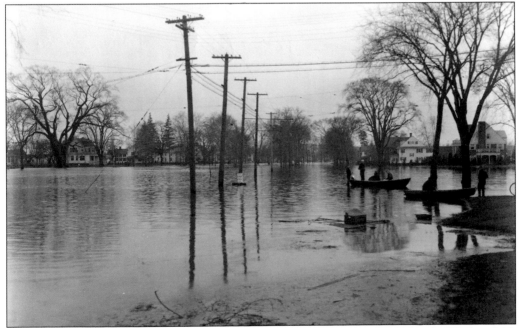

On March 21, 1936, the Connecticut River reached the record height of 37.56 feet. In Wethersfield, Middletown Avenue, Marsh Street, River Road, and Elm Street were completely underwater. Broad Street Green, seen in this photograph, became a lake. Small boats and canoes were important rescue vehicles, helping residents reach safe ground.

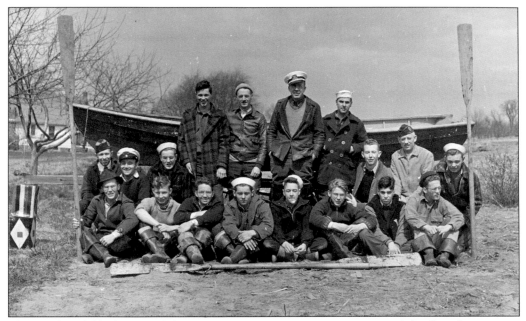

The Wethersfield chapter of the Sea Scouts, a senior scout program of the Boy Scouts, was founded in 1933. The scouts learned sea trades, including sailing, navigation, boatbuilding, motor repair, knot tying, and mending sails. The scouts trained on real boats and on a ship deck installed at the American Legion. During the flood of 1936, officers and Sea Scouts pose in front of their rescue boat donated by the Wethersfield Rotary Club. (Courtesy of Russell Partridge.)

The Great Elm was believed to have been planted by John Smith in 1758. By 1930, it was the largest elm tree in the United States, with a circumference of 48 feet, an estimated height of nearly 125 feet, and limbs spreading 165 feet. After the tree was damaged during the 1938 hurricane, it was discovered that it had Dutch elm disease. It survived until 1953, when it was finally removed.

In 1938, Wethersfield was hit with the first significant hurricane to strike the area since 1869. The category-three hurricane killed over 682 people, mostly in Rhode Island, and damaged or destroyed over 57,000 homes in New England. The high winds also damaged natural landmarks, including the Wethersfield Great Elm, seen in this photograph.

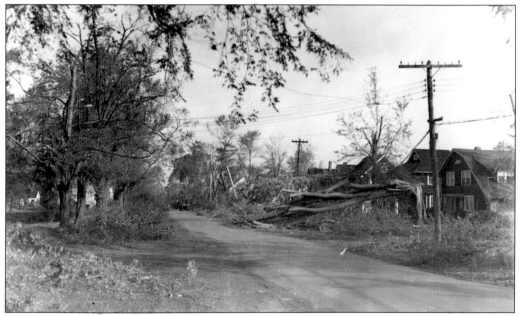

Downed power lines and trees were a common sight after the hurricane of 1938 finished inflicting havoc on New England. Also, with the memories of the flood of 1936 still fresh in residents' memories, Wethersfield again had to contend with floodwaters. During the hurricane of 1938, Connecticut's inland towns, including Wethersfield, experienced widespread flooding as the Connecticut River overflowed its banks between Hartford and Middletown.

Through the years, the Wethersfield Cove has served not only residents but also boating enthusiasts from throughout the area. A natural safe haven, many moor their vessels at the cove, gaining access to the Connecticut River through a small channel. Sailboats and motorboats have plied these waters, enjoying a leisurely trip up and down the popular river.

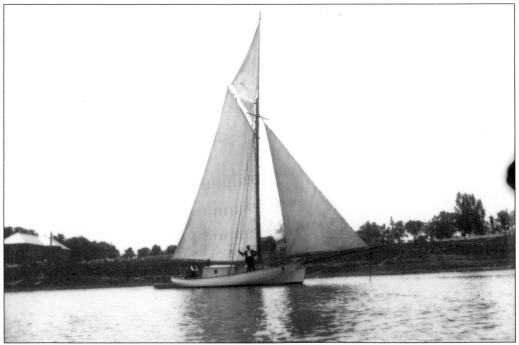

The Hannum Boatyard, the Hannum Canoe Club, the Waternook Boat Club, and the Wethersfield Yacht Club were all located at the Wethersfield Cove. In 1908, 25 residents formed the Wethersfield Yacht Club, and by 1910, membership grew to 103. For the enjoyment of all boaters, yacht club members lobbied for improvements, such as keeping the channel properly dredged and installing lights at the cove entrance.

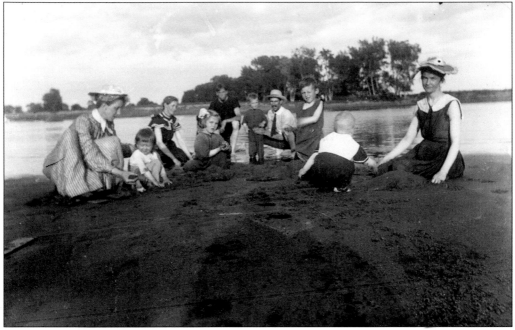

A popular recreation area, the Wethersfield Cove and the Connecticut River were ideal spots for fishing, canoeing, sailing, swimming, and skating. Here the members of the Standish family relax on a sandbar in the river just north of the cove around 1903.

Katherine and Charlotte Buck, seen canoeing on the Wethersfield Cove around 1925, are descendants of Wethersfield farmers and fishermen. As children living near the cove, the Buck sisters learned to row and sail at this popular recreation spot. Children even swam in the cove before pollution became a problem.

Members of the Wethersfield Racquet Club pose on the Broad Street Green. Founded in 1891, the club promoted the interest of lawn tennis playing. Tennis was first played in the United States in 1876, becoming very popular, especially among the upper class, in the last two decades of the 19th century.

Bicycling took America by storm toward the end of the 19th century. Early penny-farthing models, with a large wheel in front and a small one in back, proved to be unsteady and often dangerous. In 1893, the invention of the safety bicycle, one with two wheels of equal size, offered people, especially women and children, an affordable, enjoyable method of recreation and transportation.

The Wethersfield Grange began in 1890 to provide support to farmers by promoting cooperatives, education, and social activity. After meeting at the Old Academy for many years, members built their own hall in 1898 for $3,824. The Grange met every other Tuesday, attracting many Wethersfield residents to their lively meetings.

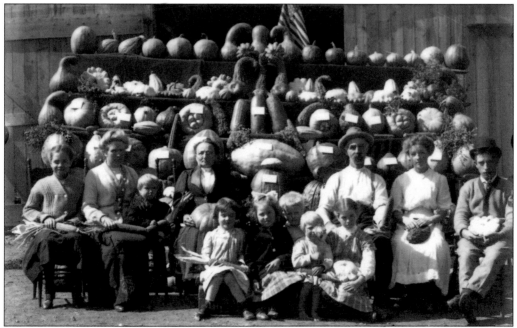

Grange members enjoyed music, drama, and debates in addition to tradition agricultural fairs. They also distributed Thanksgiving and Christmas baskets and sponsored a garden club and farmer's cooperative. This early-20th-century photograph shows Grange members with a display of locally grown produce.

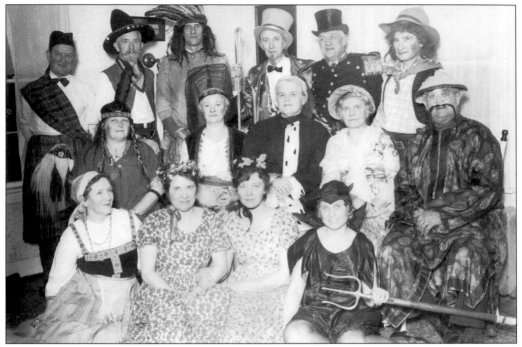

In the early 20th century, the Wethersfield Grange focused more on social activities, celebrating Halloween, Christmas, and New Year's Eve together. This photograph shows Grange members dressed for a costume party in 1937. (Courtesy of George Clark.)

Square dancing developed from the various national dances settlers brought with them to America. Often a prompter would need to cue dancers, calling out the steps. Eventually dances for four couples with a caller were developed. In the 1930s, Henry Ford became interested in the revival of square dancing, leading to its newfound popularity. Officers of the Wethersfield Square Dance Club pose for this photograph in 1960.

Community theater, a term coined in 1917, has it roots in the late 19th century. In the 1920s and 1930s, it really flourished with over 100 community theaters founded in America. The Wethersfield Community Players was established in 1932 and offered a variety of plays and Broadway musicals at local schools. In this photograph, members are staging *The Detective Story*.

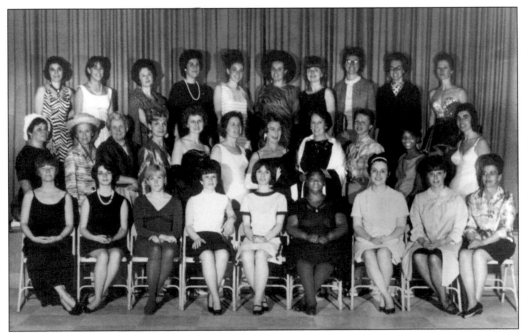

In the 1960s, members of the Wethersfield Community Players pose for a formal photograph. To undertake a theater production, members not only performed the parts, they also created the stage sets, rehearsed tirelessly, handled publicity, prepared programs, and sold tickets. The players enjoyed the camaraderie of a busy theater schedule.

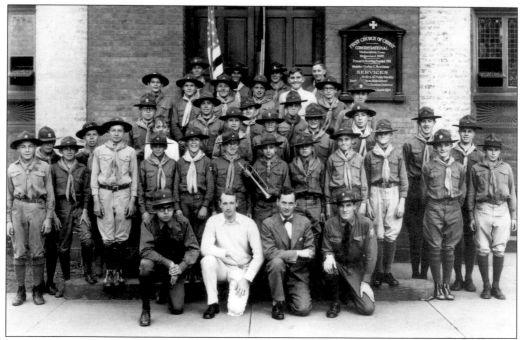

The Boy Scouts of America was founded in 1910 to train young men in citizenship and to provide self-reliance through participation in outdoor activities. The Wethersfield Troop 33 of the Boy Scouts of America pose for this photograph in front of First Church of Christ in 1926.

Richard B. Lasher, member of Boy Scouts Troop 50, with his younger brother Thomas, poses before the 300th anniversary parade in 1934. Richard has lived in Wethersfield his whole life and owned and operated his own distribution company. He is the self-proclaimed honorary mayor of Griswoldville. Thomas, an insurance executive, worked tirelessly on behalf of the disabled. (Courtesy of Richard B. Lasher.)

Wethersfield Boy Scouts climb the signal tower at First Church's Brick Fair in 1979. From left to right are (first row) Joe Quirk, Phil Allegreth, Rick Doblor, and Ken Meade; (second row) Todd Bruce and an unidentified Scout. Physical activities to build character and develop personal fitness are an important part of Scouting. (Courtesy of Wethersfield Boy Scouts.)

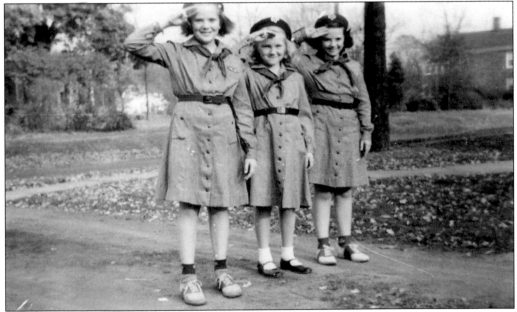

Three friends pose in their Girl Scout uniforms. From left to right are Barbara Judson McLean, Carolyn Anderson Bountress, and Ann Nichols Decellis. Although this photograph dates from the mid-1940s, the Girl Scouts was established in 1912. Juliette Gordon Low formed the organization to bring girls into community service and the open air through a variety of activities. (Courtesy of Barbara McLean.)

The Emerson-Williams Brownie Troop No. 10253 participates in a field trip at the Eleanor Buck Wolf Nature Center. The nature center is an environmental education facility that offers educational services to the community. From left to right are (first row) Allison Ayers, Kelly Scales, Erin Nargi, center director Christopher Shepard holding Sweety the turtle, Alexandra Cristofaro, and Rachel Vasel; (second row) Katie Galusha, Katie Ginter, Emily McKenna, Chloe Hendron, and Hannah McGrath. (Courtesy of Janet Vasel.)

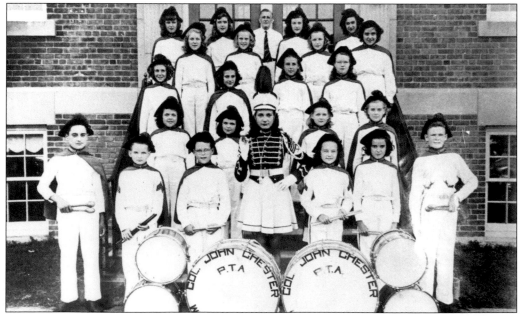

The Col. John Chester Fife and Drum Corps began in 1940. The corps was supervised by the Col. John Chester School and the Exchange Club until 1960, when it became self-sustaining. The corps includes fifers, snare drummers, bass drummers, and a color guard. The corps participates in parades, competitions, and musters. It plays music from the pre-Revolutionary era to the Civil War period. (Courtesy of Col. John Chester Fife and Drum Corps.)

The Col. John Chester Fife and Drum Corps performs at Corn Fest on the Broad Street Green in Wethersfield. Corn Fest, sponsored by the Wethersfield Chamber of Commerce, began in 1984. Local businesses and community organizations participate in this town-wide event, which unites the community in the celebration of Wethersfield.

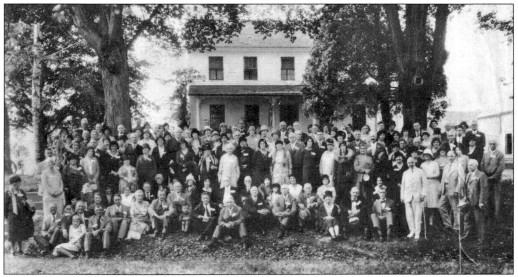

The descendants of Edward, Matthew, and Michael Griswold, 17th-century settlers of Wethersfield, Windsor, Saybrook, and Killingworth, held their first-annual family reunion in Wethersfield in 1930. The gathering at Union Chapel in the Griswoldville section of Wethersfield was attended by 125 family members and guests.

Nina DiMascio, who immigrated to Connecticut from Italy in 1972, established the Italian Culture Center to teach the Italian language and culture to area residents. In this 2001 photograph, children in traditional costume participate in family night at the end of the school year. Nina DiMascio met and married Erminio DiMascio and lived in the Italian south end of Hartford before moving to Wethersfield. (Courtesy of Nina and Erminio DiMascio.)

Steve Yatrousis and Gloria Pitchell, copresidents of the Wethersfield Art League, show a piece of art to be displayed at the St. George Greek Orthodox Cathedral Fair in 1976. The Wethersfield Art League, founded in 1958, continues to display members' artwork at a variety of venues, including the Wethersfield Museum at the Keeney Memorial Cultural Center. St. George's, established in Hartford in 1898, counts many Wethersfield residents as members. (Courtesy of Priscilla Kokinis.)

The Wethersfield Festival celebrated the diversity of the town's history and culture each spring. From 1998 to 2002, the town gathered for a weekend-long, multifaceted event that incorporated the history museums, live music, crafts, antiques, demonstrations, and activities for children. A highlight of the annual event often included a living-history presentation of a Revolutionary-era encampment and battle reenactment. The international aspect of the festival reflected the town's cultural and ethnic diversity over the past 100 years through art, music, food, and dance. Above, girls of Portuguese heritage prepare for their dance performance in 2001. Below, dressed in traditional costume, women of Polish heritage prepare their table of cultural articles, including dolls, painted eggs, and woodcrafts in 1998. (Photographs by Lois Clarke, courtesy of Wethersfield Historical Society.)

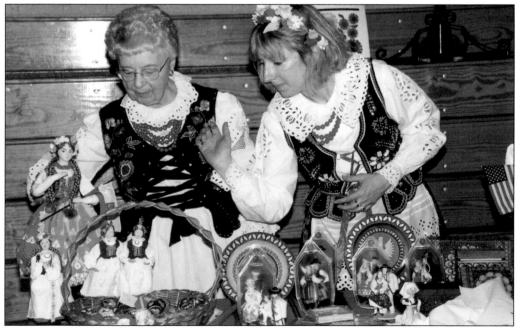

The Old Wethersfield Shopkeepers Association, founded to promote businesses in the historic village, has presented a variety of community activities. In this photograph of 1989 Vintage Wethersfield Day, participants perform in costume in front of the Baskin Block on Main Street. Identified people include Carol Bittner on the far left and Leslie Watson on the far right. The shopkeepers also sponsor the popular Scarecrows Along Main Street event each year. (Courtesy of Barbara Ford.)

The Wethersfield Men's Garden Club began in 1956 with 14 charter members. The club, which meets to exchange ideas about home gardening and landscaping, has been active in community projects. In this photograph, club members work on the Hurlbut-Dunham House's garden, a house museum owned by Wethersfield Historical Society. Since 1983 the club has cared for the Frank Weston Memorial Rose Garden next to Wethersfield's town hall.

The Village Improvement Association was formed in 1882 to care for the public grounds of Wethersfield and to promote public improvements. In a similar vein, local garden clubs were established to share a love of gardening and to participate in community projects. The Bud and Blossom Garden Club, established in 1958, is one of seven active garden clubs in town. In this photograph, Bud and Blossom members celebrate their 50th anniversary in 2008. (Courtesy of Bud and Blossom Garden Club.)

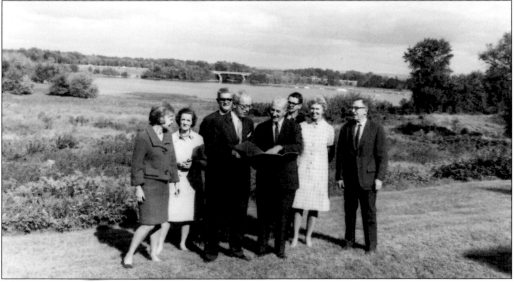

The Great Meadows Conservation Trust was founded in 1968 by residents of Wethersfield, Rocky Hill, and Glastonbury to protect the floodplain known as the Great Meadows. The trust's mission is to preserve agricultural, scenic, archaeological, and wetland resources. Trust founders include, from left to right, Betty Brown of Glastonbury; Marion Flaherty of Wethersfield; Henry S. Beers, chairman, of Glastonbury; Joseph Hickey of Wethersfield; Felix Montano of Rocky Hill; Russell Brenneman of Glastonbury; Eleanor Buck Wolf, secretary, of Wethersfield; and Charles Crosier of Rocky Hill. (Courtesy of the Great Meadows Conservation Trust.)

Basketball began in 1891 in nearby Springfield, Massachusetts. A perfect sport for New England, basketball enabled athletes to play an indoor game during the winter months. The 1943 Wethersfield High School junior varsity basketball team poses for a photograph. From left to right are (first row) Bob Priddy, Art Kearns, Joe Bell, Cephas Gagne, and Sunny McCue; (second row) unidentified, Mark Fish, Don McKelvie, Howard McKee, and coach George Ritchie. (Courtesy of Millard Mason.)

American football, developed from rugby football, began in the mid-19th century. Regulations changed over time, including introducing the line of scrimmage and down-and-distance rules to the game. This photograph from about 1930 of the Wethersfield Athletic Club football team shows the limited protective uniform utilized in the early 20th century as compared to today.

America's favorite pastime, started in the United States in the 1860s, was a popular sport in Wethersfield. One of the high school baseball teams from the 1930s poses for a photograph. From left to right are (first row) Tony Vicino, Ed Bergendahl, George Stenstrom, unidentified, Carl Haertel, and unidentified; (second row) E. Gilbert Farren (manager), Joe Gaslow, Jim Rankin, Joe McCue, Bob Hungerford, George Cummings, and coach George Ritchie. (Courtesy of Millard Mason.)

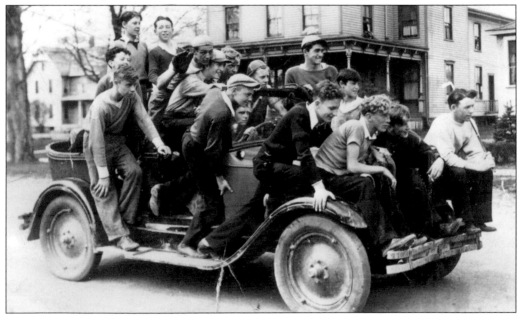

Possibly of a float in the Memorial Day parade, this photograph was taken at the corner of Garden and Church Streets in Wethersfield. Most of the boys on the car were members of the Wethersfield Athletic Club baseball teams. The Wethersfield Athletic Club offered a variety of popular team sports for young men to participate in, such as baseball, basketball, and football. (Courtesy of Elizabeth Baboval.)

The Wethersfield Country Club, seen in this 1983 Greater Hartford Open photograph, was organized in 1916. Robert D. Pryde was hired to lay out a nine-hole golf course, and Philip A. Mason was the architect for the clubhouse. Both opened in June 1917. In 1924, the club purchased land for an additional nine holes designed by Jack Stait, a Hartford Golf Club professional. (Courtesy of Debbie May.)

New England's premier golf tournament began in 1952 as the Insurance City Open at the Wethersfield Country Club. It later became known as the Greater Hartford Open (GHO) in 1967 then the Sammy Davis Jr. GHO in 1973. From left to right, former GHO champion Dave Stockton, Travelers Insurance Company president Harrison Beech, Pres. Gerald R. Ford, honorary GHO chairman Howard Winterson, and entertainer Bob Hope pose during Pro-Am Day in 1978. (Courtesy of Wethersfield Country Club.)

Celebrities made appearances, sharpened their skills, and proved to be a popular draw for the GHO. Attendees posing at the 1983 Celebrity Pro-Am, from left to right, are Debbie May, Ted May, Sammy Davis Jr., Altovese Davis, Tim Norris, Harry Gray, Helen Gray, and Bob Hope. The GHO was organized and run by the Greater Hartford Jaycees, and funds raised at the tournament support many projects in the capital area. (Courtesy of Debbie May.)

Curtis Strange was the champion of the last GHO tournament played at Wethersfield Country Club in 1983. The following year, the tournament moved to Cromwell. From left to right, the final award ceremony photograph shows Helen Gray, Debbie May, Harry Gray, champion Curtis Strange receiving his check, and chairman Ted May. (Courtesy of Debbie May.)

The town's first funeral home, D'Esopo Funeral Chapel, was founded by Italian immigrants Joseph and Mary Pellettieri D'Esopo in 1905. The family business was originally located in Hartford and then relocated to Wethersfield in 1976. As part of the 100th anniversary celebration in 2005, the funeral chapel created a time capsule containing contributions from several organizations. Placing items in the capsule are, from left to right, Dan D'Esopo, George D'Esopo, and Michael and Janet Klett. (Courtesy of D'Esopo Funeral Chapel.)

Three residents lost their lives in the 9/11 attacks in New York: Jeffrey Bittner, Richard Keane, and David Winton. The Keane Foundation was established to honor the memory of Keane and to raise funds to provide a community center for the people of Connecticut, the 9/11 Memorial Sports Center. Shortly after the attack, the entire community gathered on the Broad Street Green for a candlelight vigil on September 16, 2001. (Photograph by Dr. Ken Sokolowski; courtesy of the Keane Foundation.)

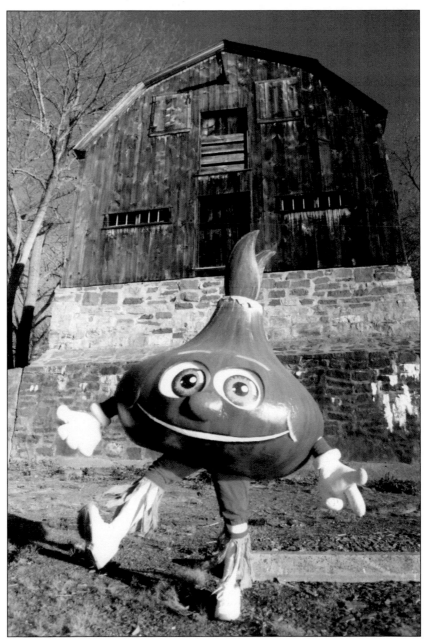

"Living with history" applies to all areas of Wethersfield and represents the town's storied heritage, as seen here in the venerable Cove Warehouse, preserved and operated as museum to educate the public about the town's rich maritime past. But living with history can also mean the modern, recent history of a town that is constantly in flux and adapting to 21st-century changes. Just below the warehouse dances the Red Onion, a colorful character that represents the town's 18th-century cash crop. A recognizable fixture for every parade and historical celebration since the 1980s, the onion is greeted with cheers from children and adults wherever he goes. The onion has endured several makeovers in recent years, but in this image, he is personified by his creator, Phil Lohman. Pairing these two great symbols of the town, one can see how Wethersfield is comfortable living with its history. (Photograph by Steve Dunn; courtesy of Phil Lohman.)

DISCOVER THOUSANDS OF LOCAL HISTORY BOOKS FEATURING MILLIONS OF VINTAGE IMAGES

Arcadia Publishing, the leading local history publisher in the United States, is committed to making history accessible and meaningful through publishing books that celebrate and preserve the heritage of America's people and places.

Find more books like this at
www.arcadiapublishing.com

Search for your hometown history, your old stomping grounds, and even your favorite sports team.